WONDERFUL FLOWERS

A Coloring Book
by Micah Buzan

Copyright© 2019 Micah Buzan
All rights reserved

ISBN: 9781092860390

The pages in this book work best with colored pencils or other dry media.

Order & Download more Coloring Books at:
https://www.micahbuzan.com/coloring-books/

Share your colored pages at:
https://www.facebook.com/groups/ColoringBooksByMicahBuzan/

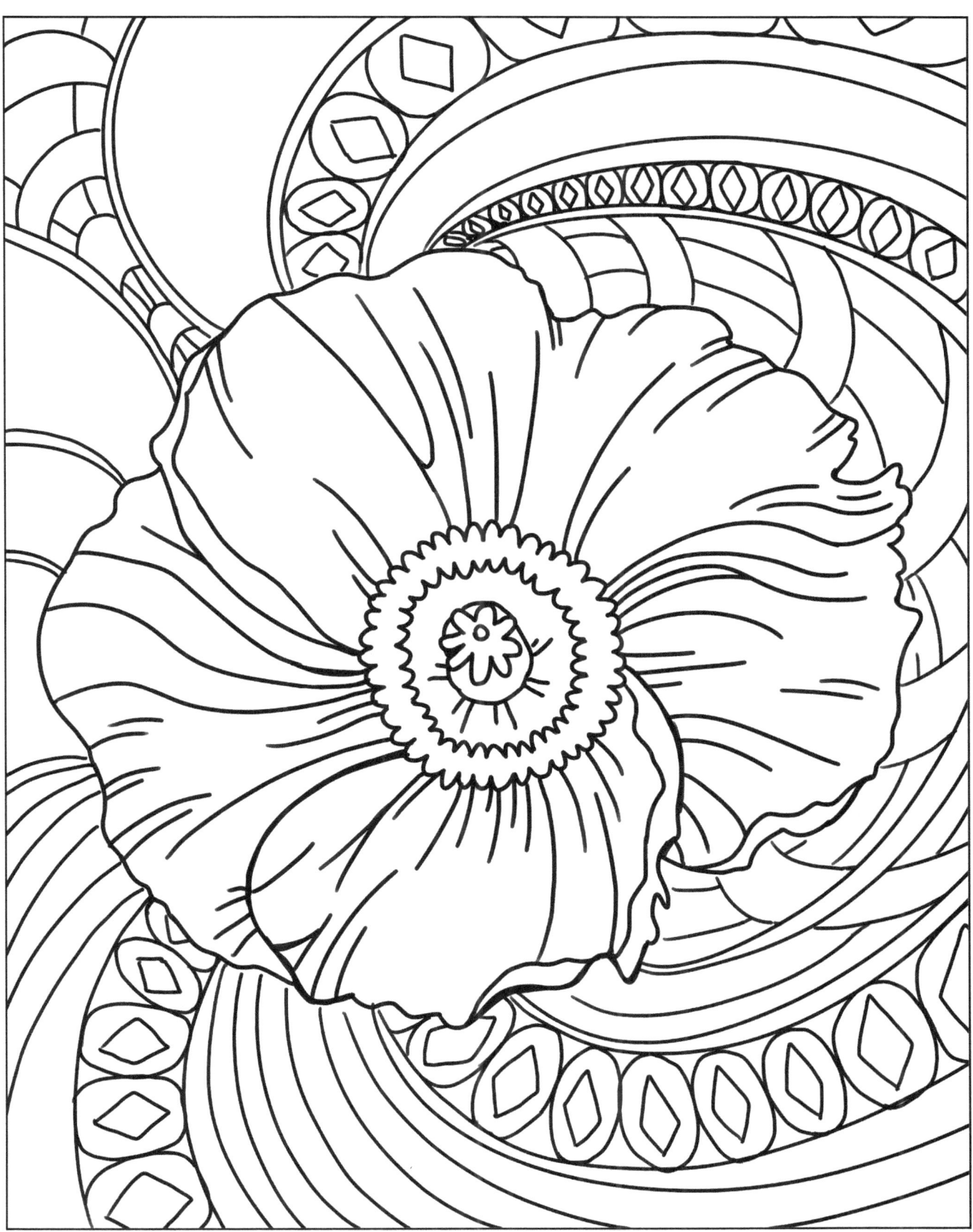

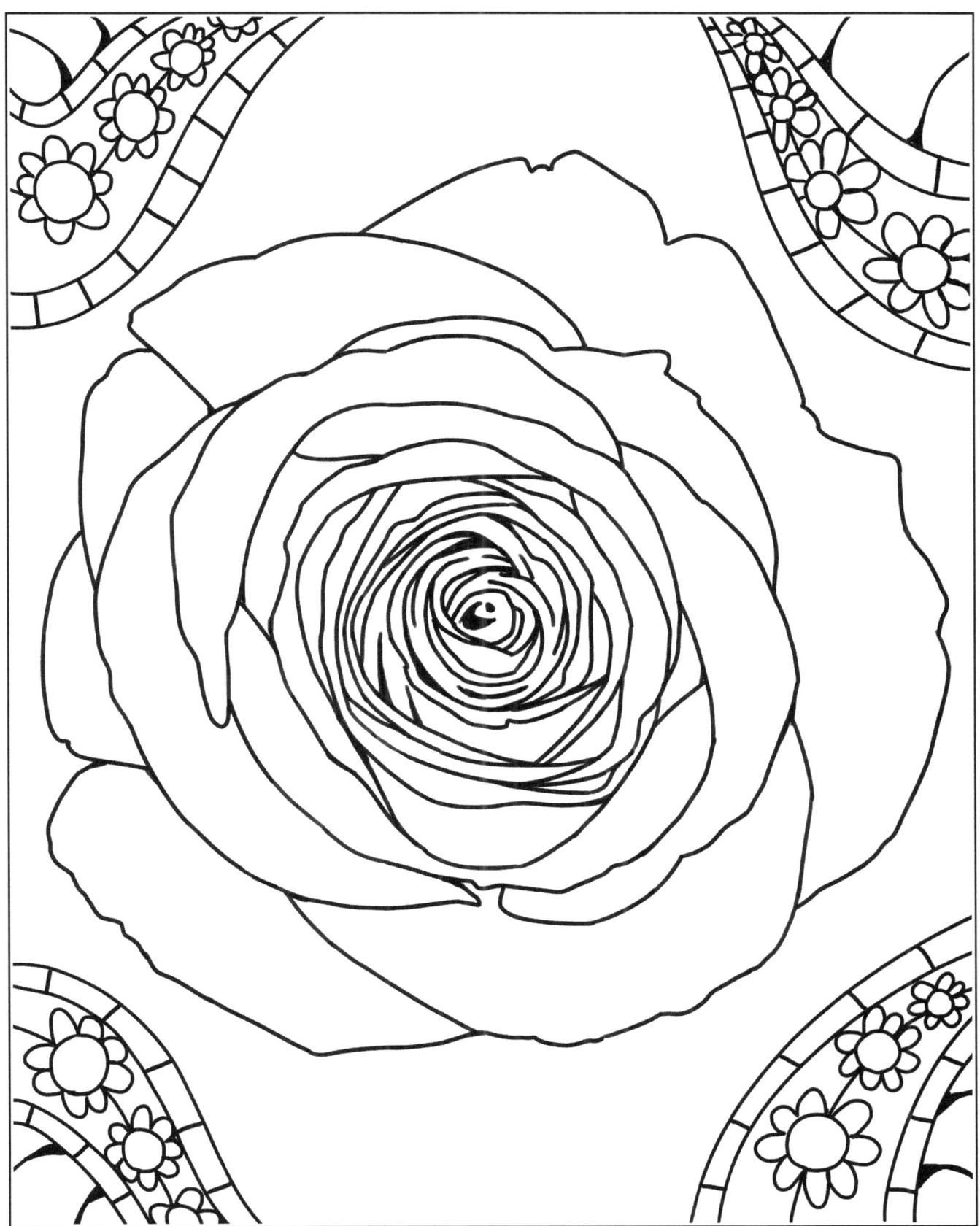

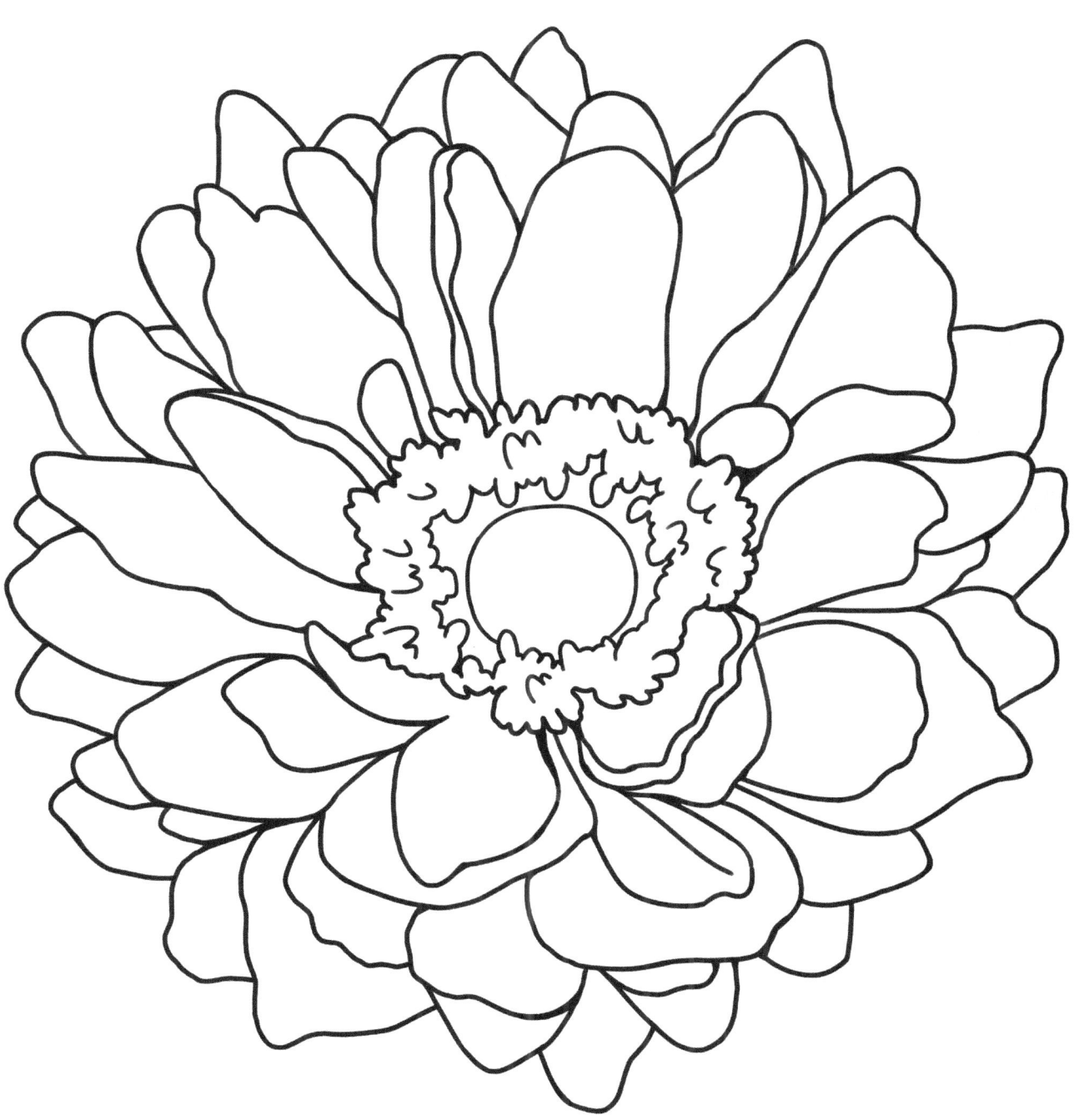

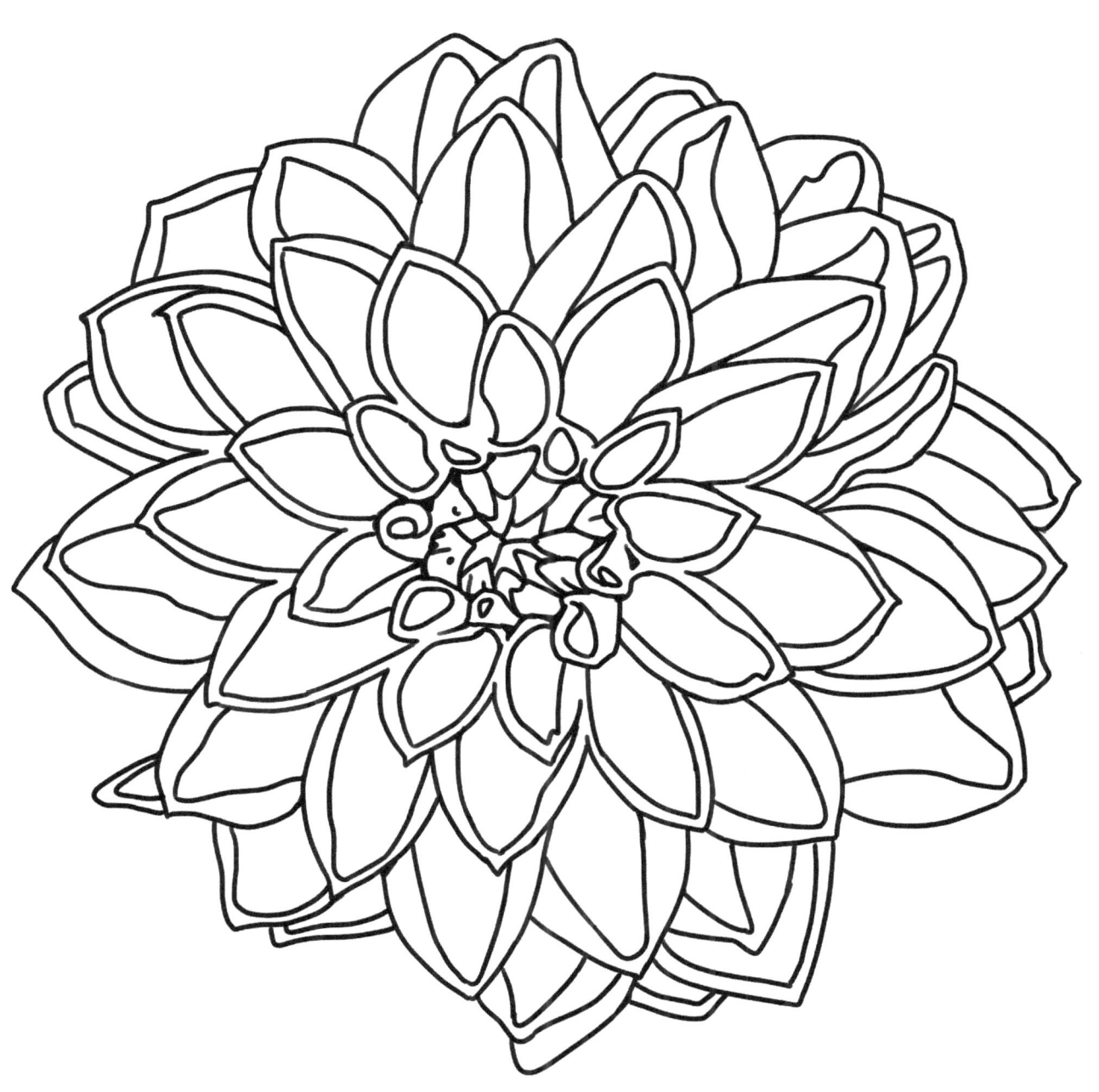

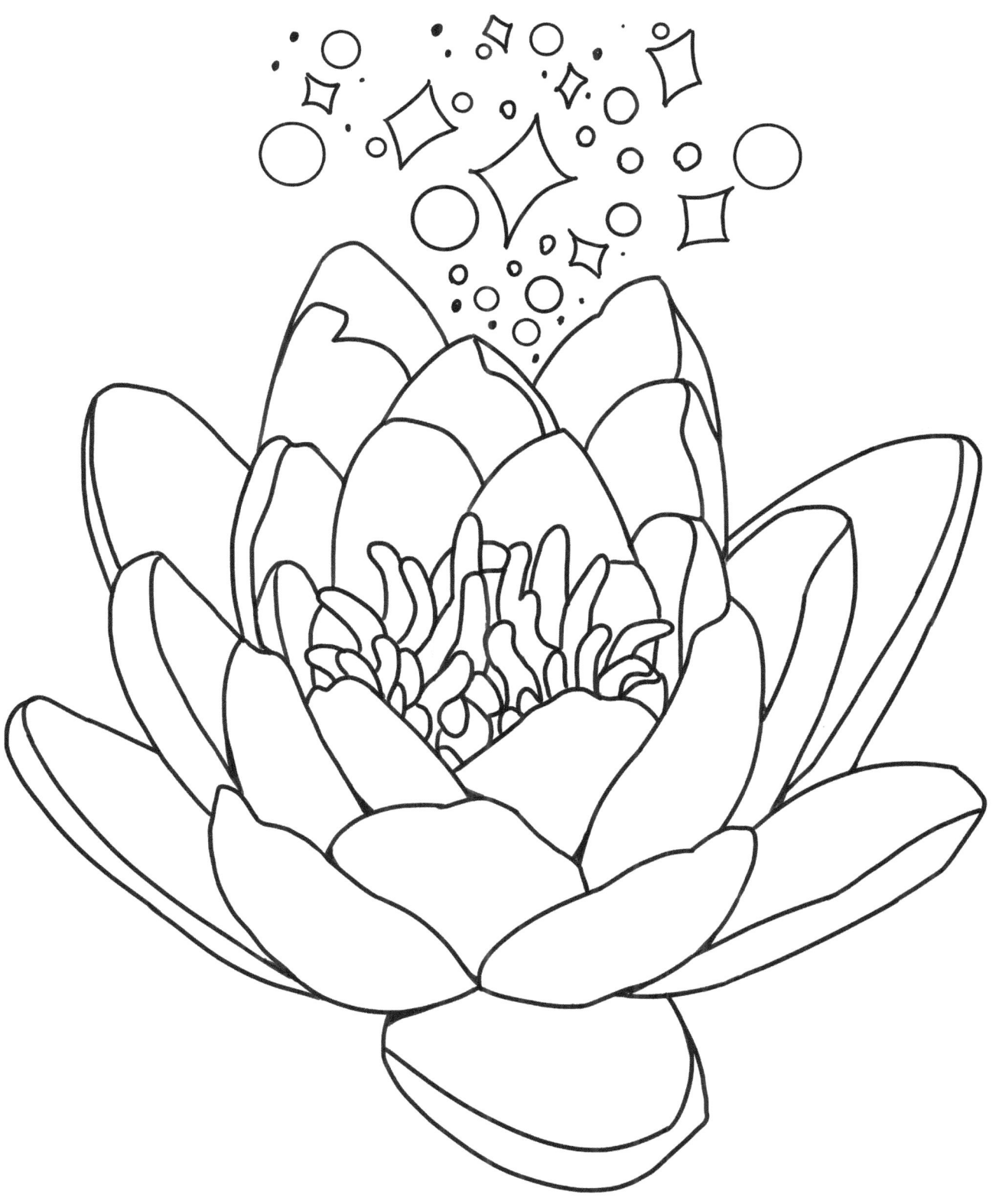

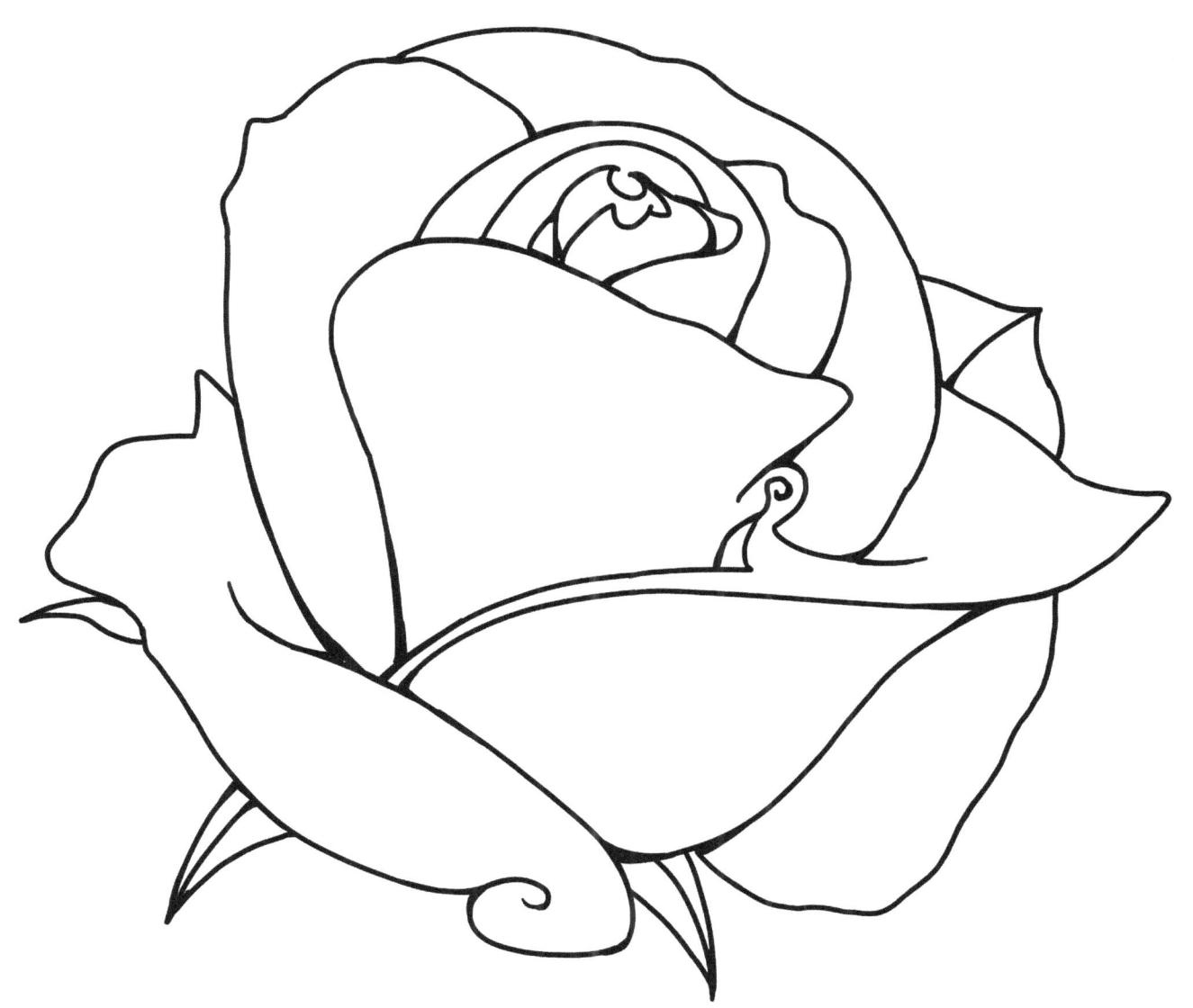

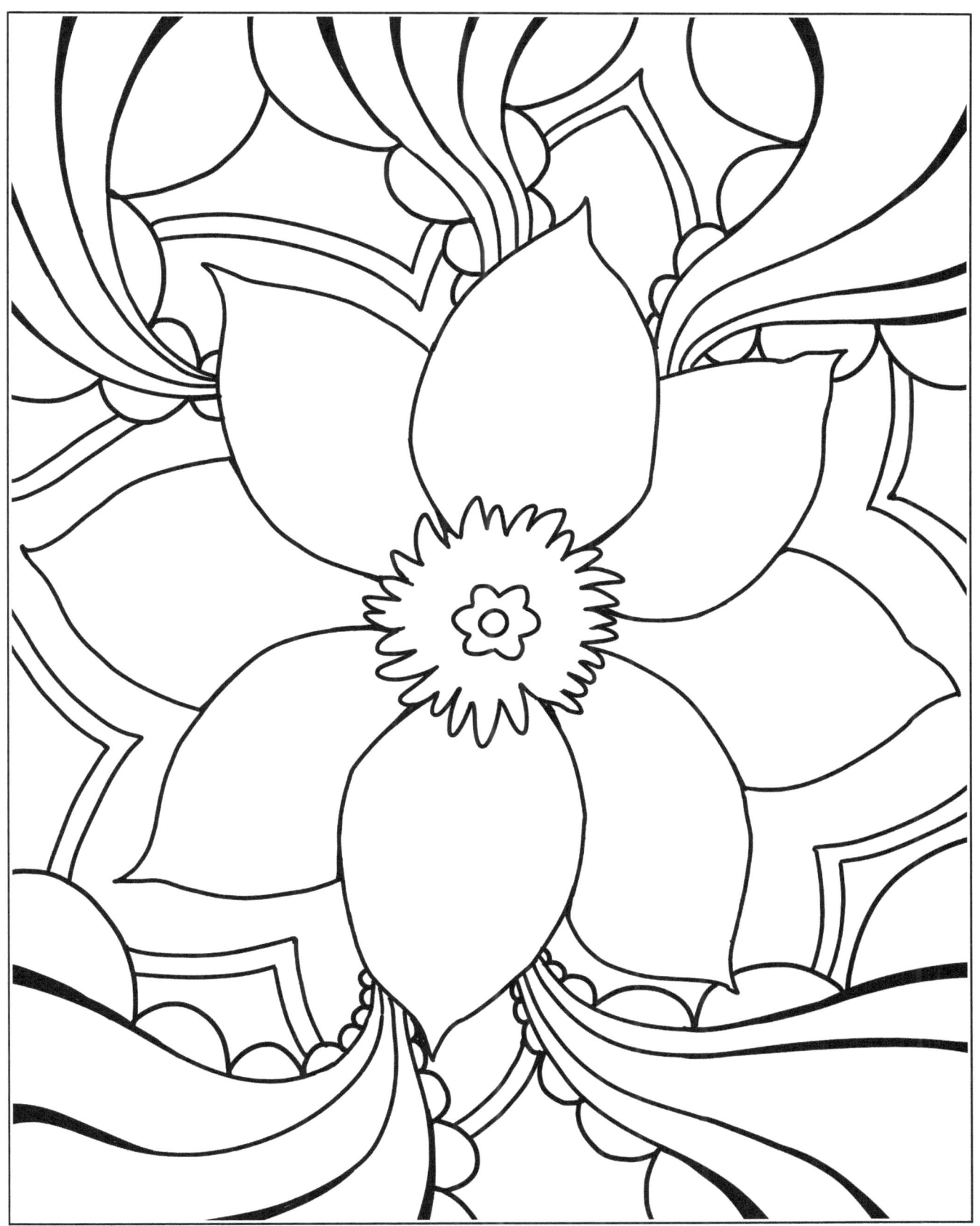

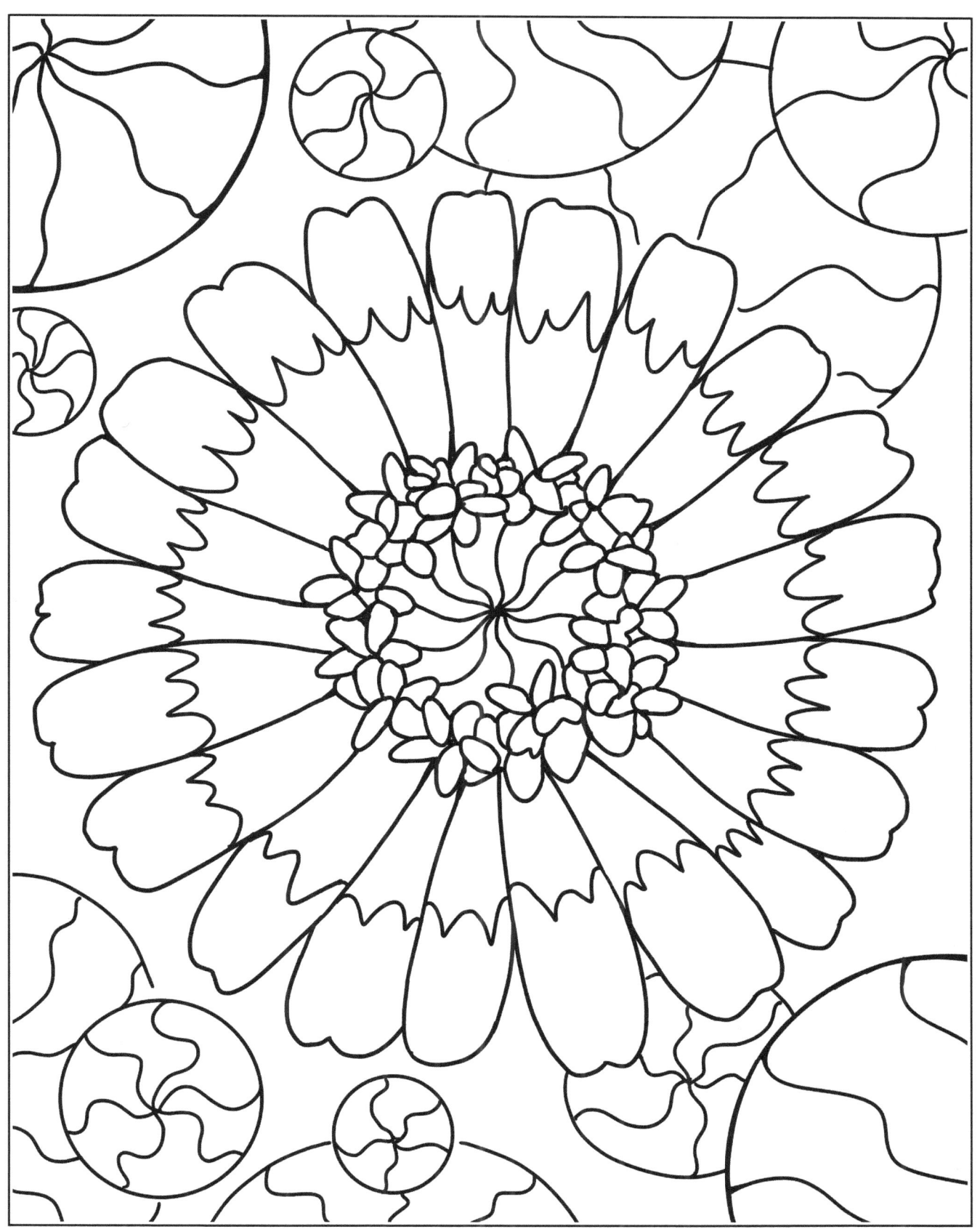

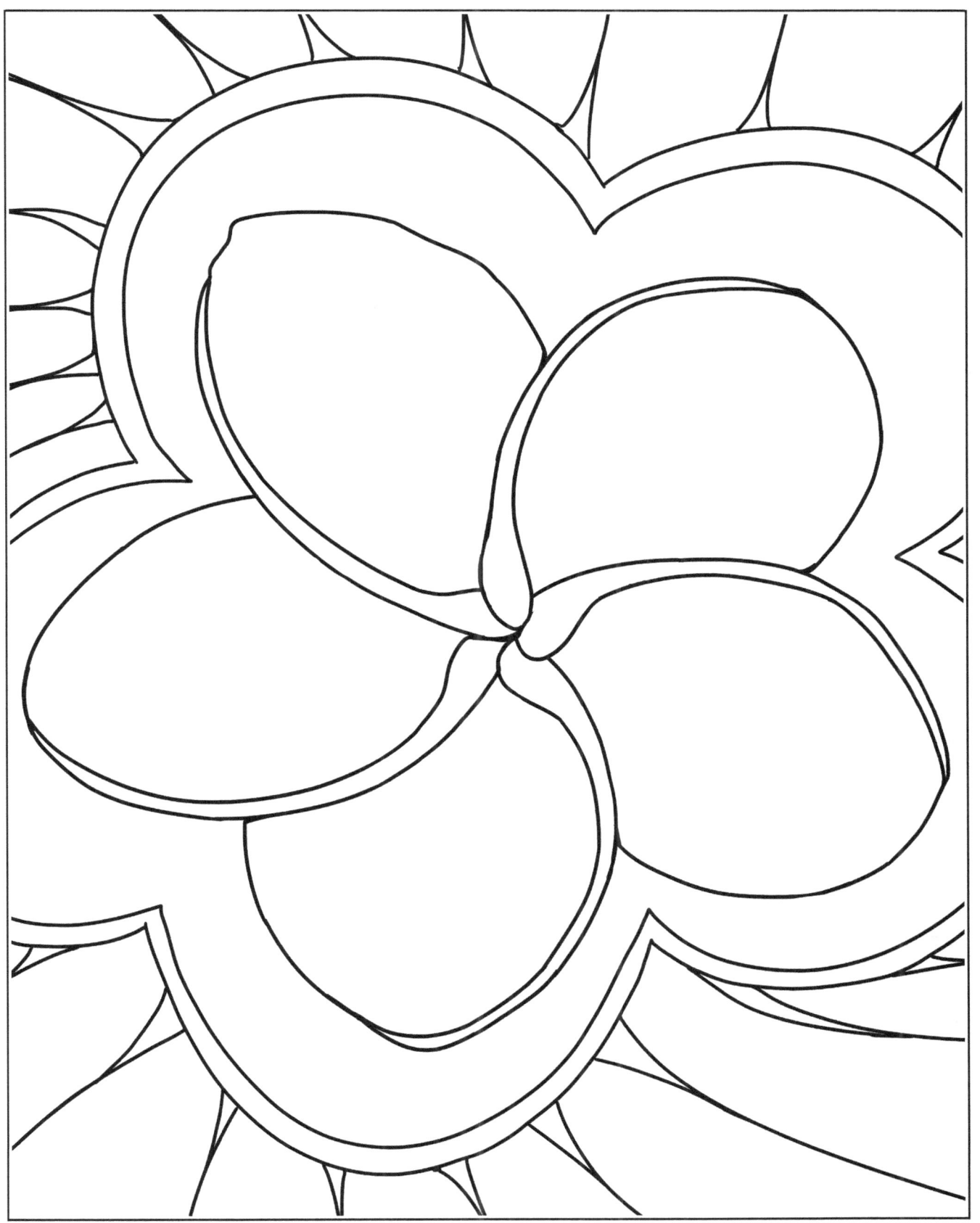

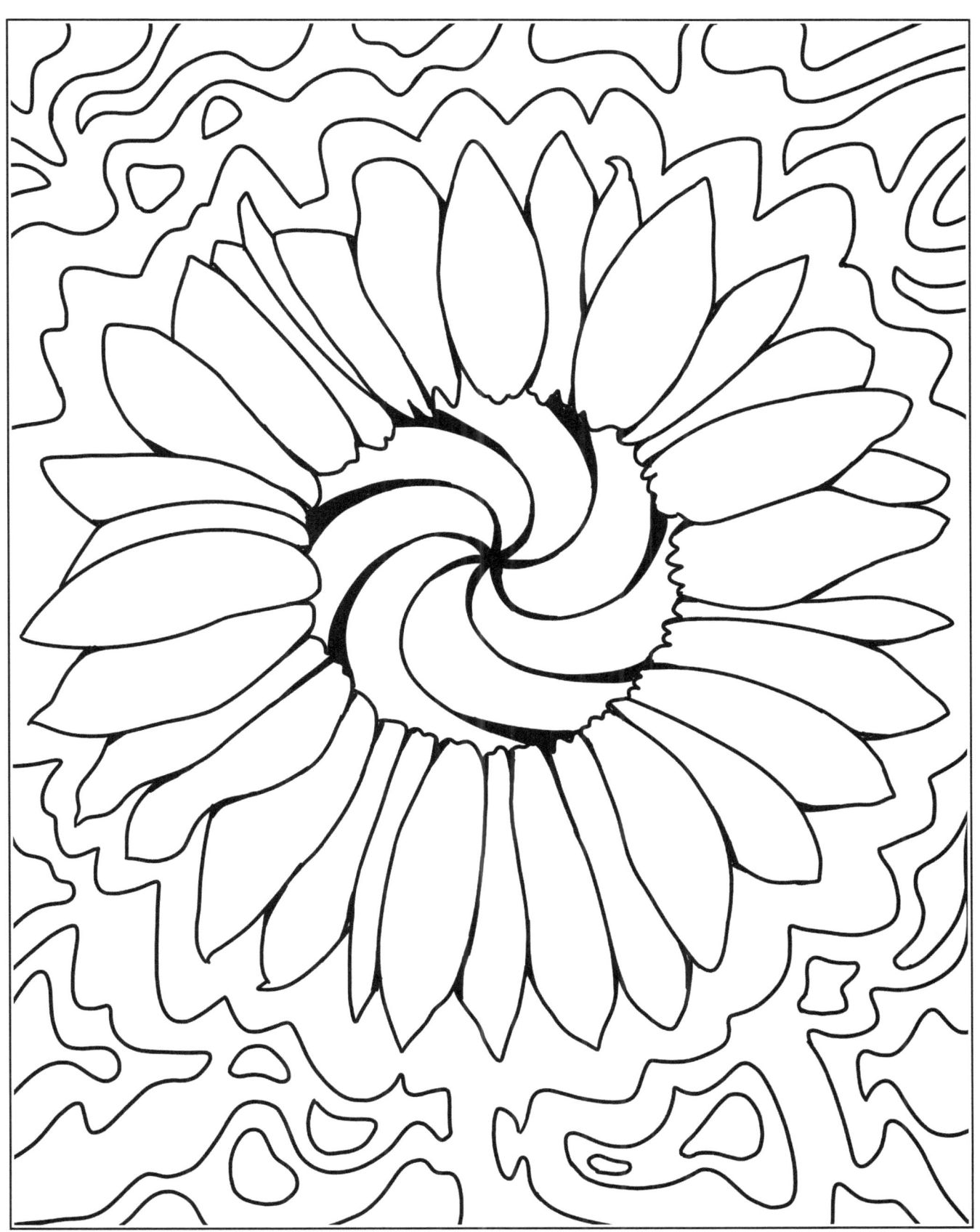

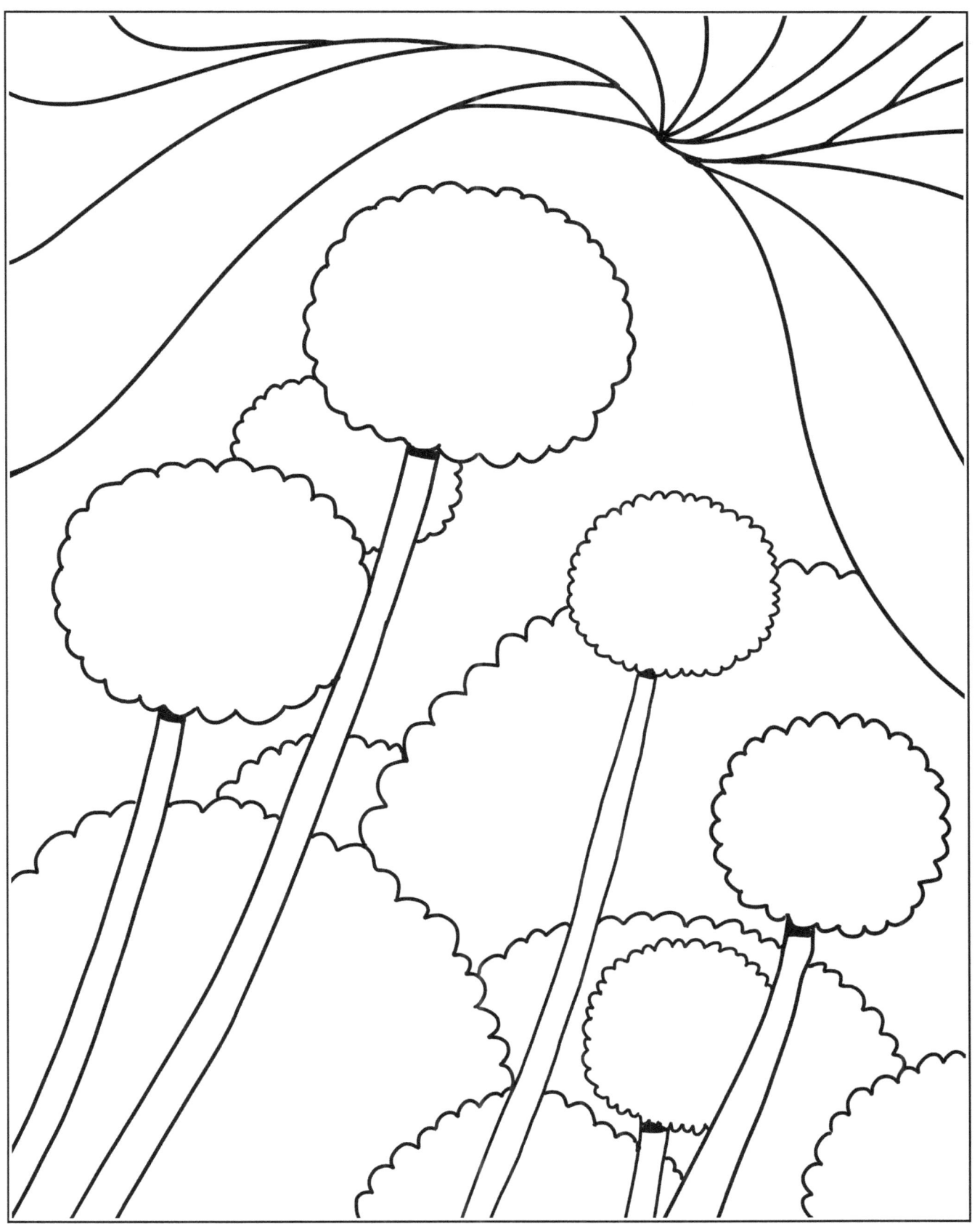

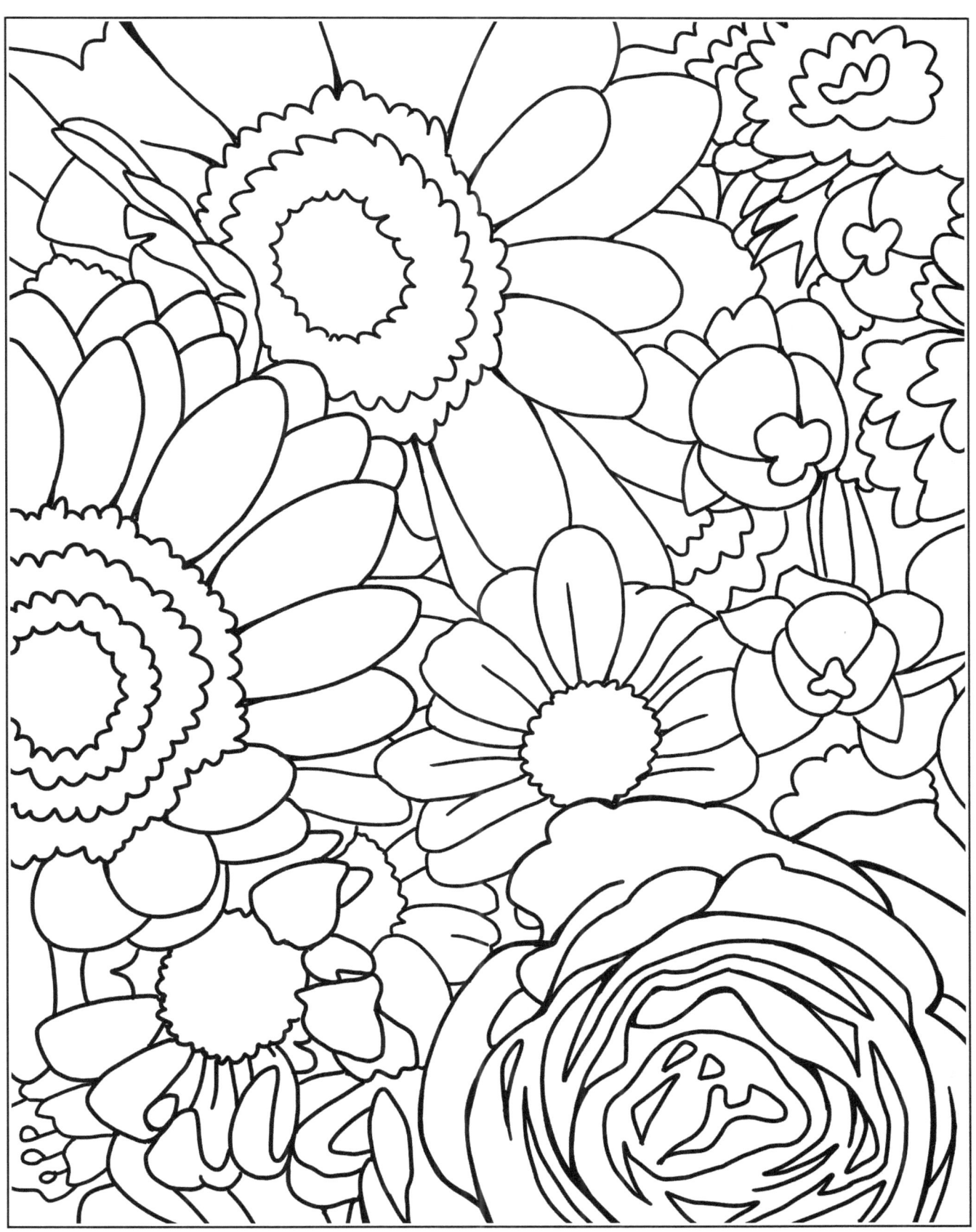

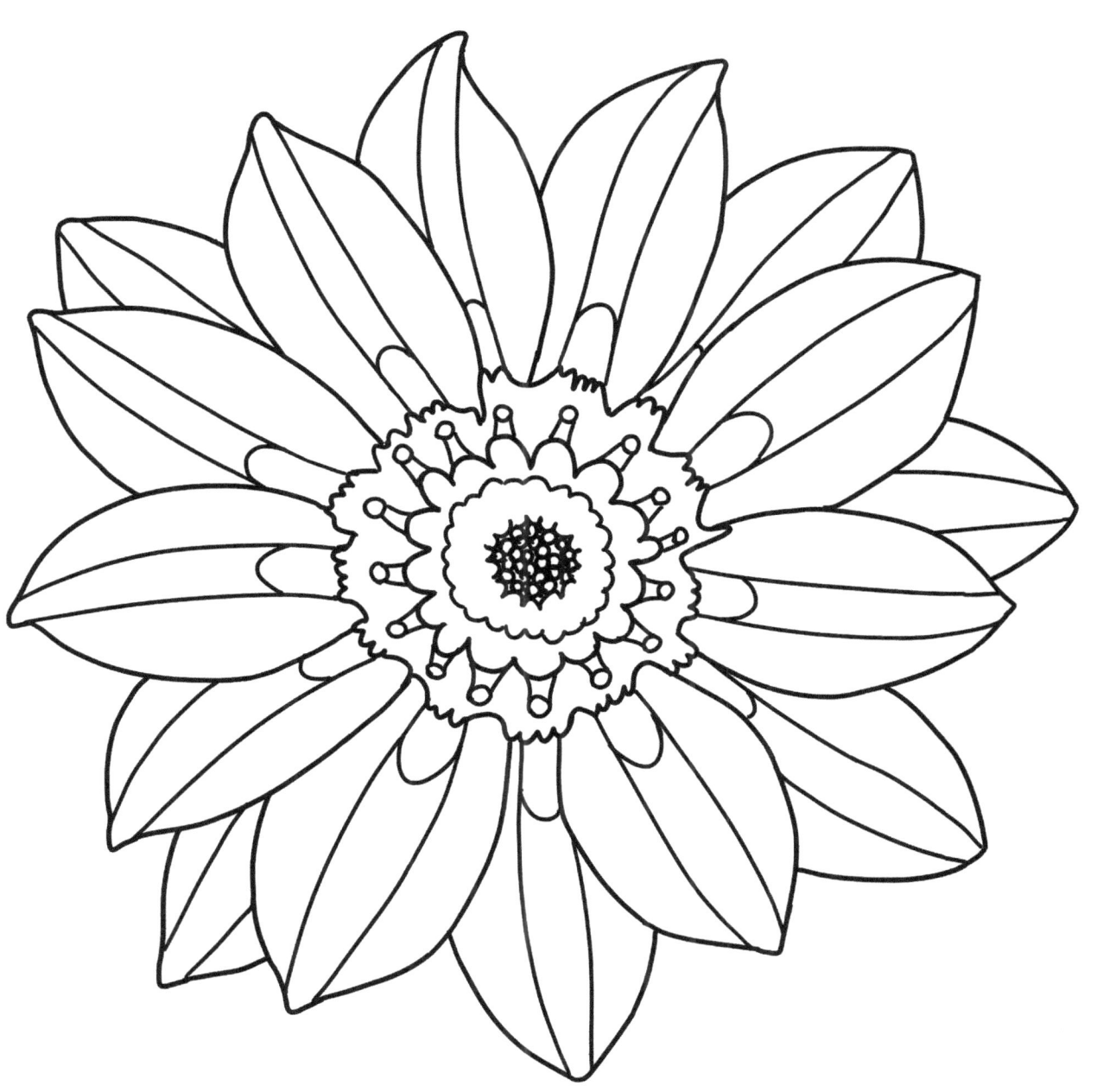

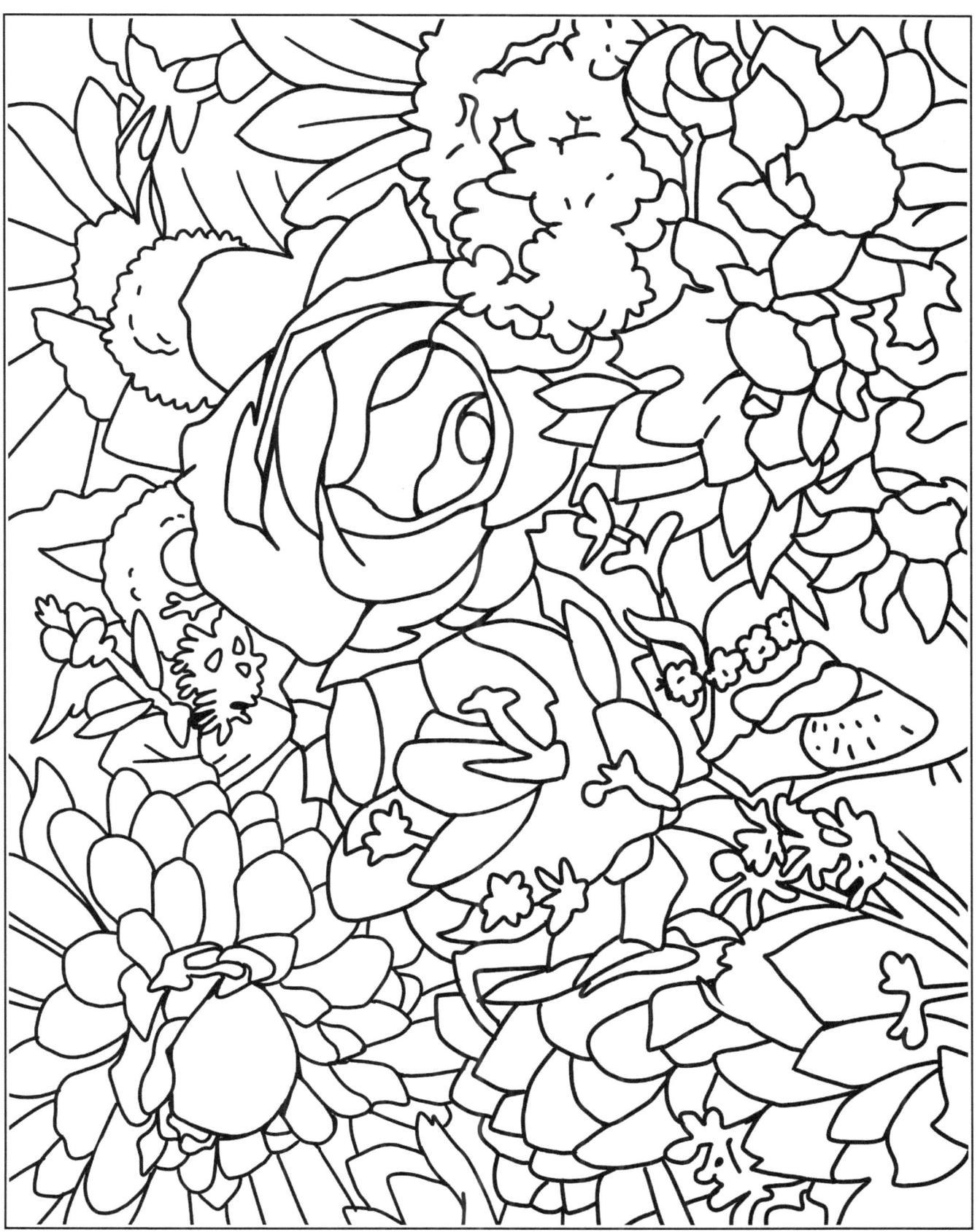

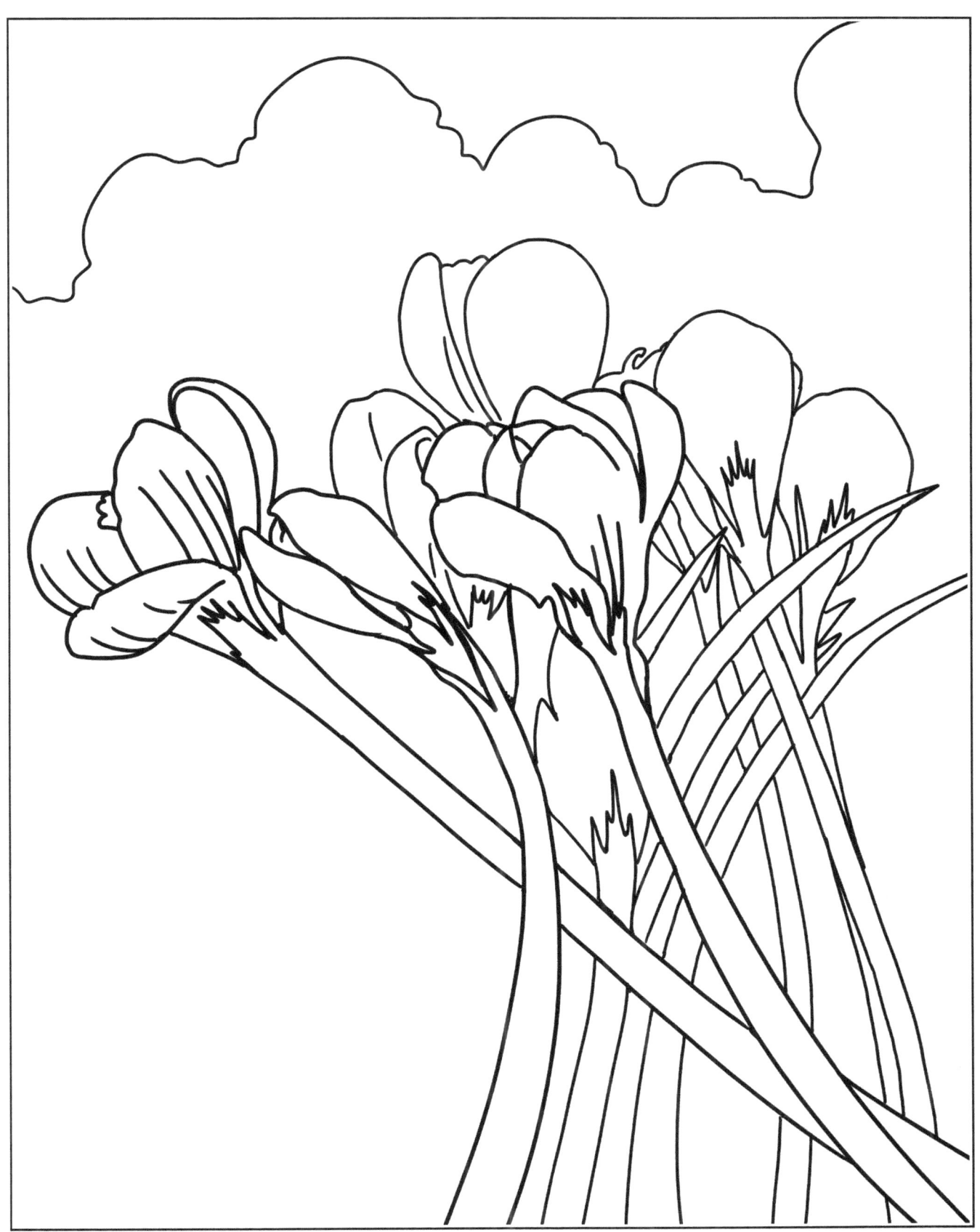

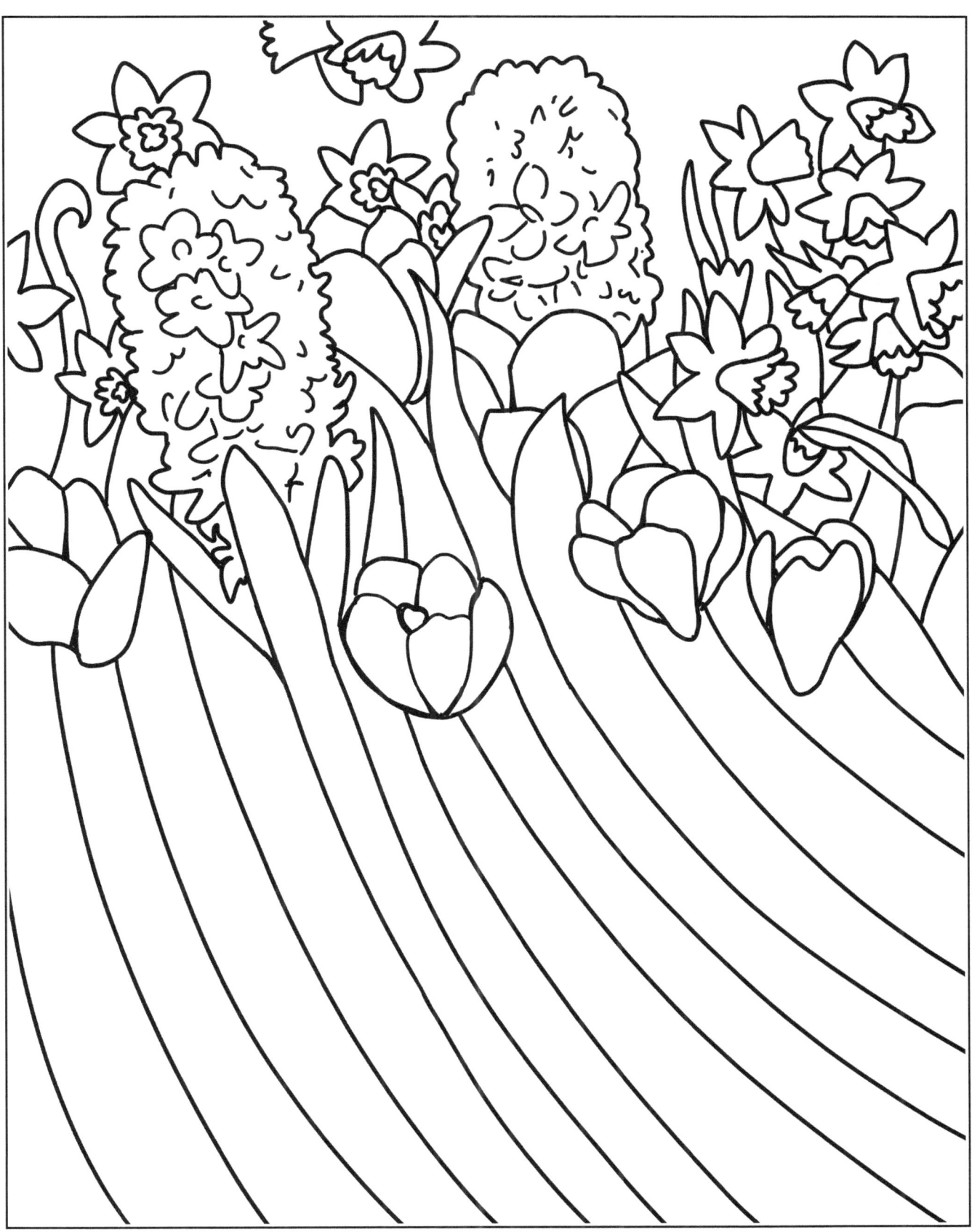

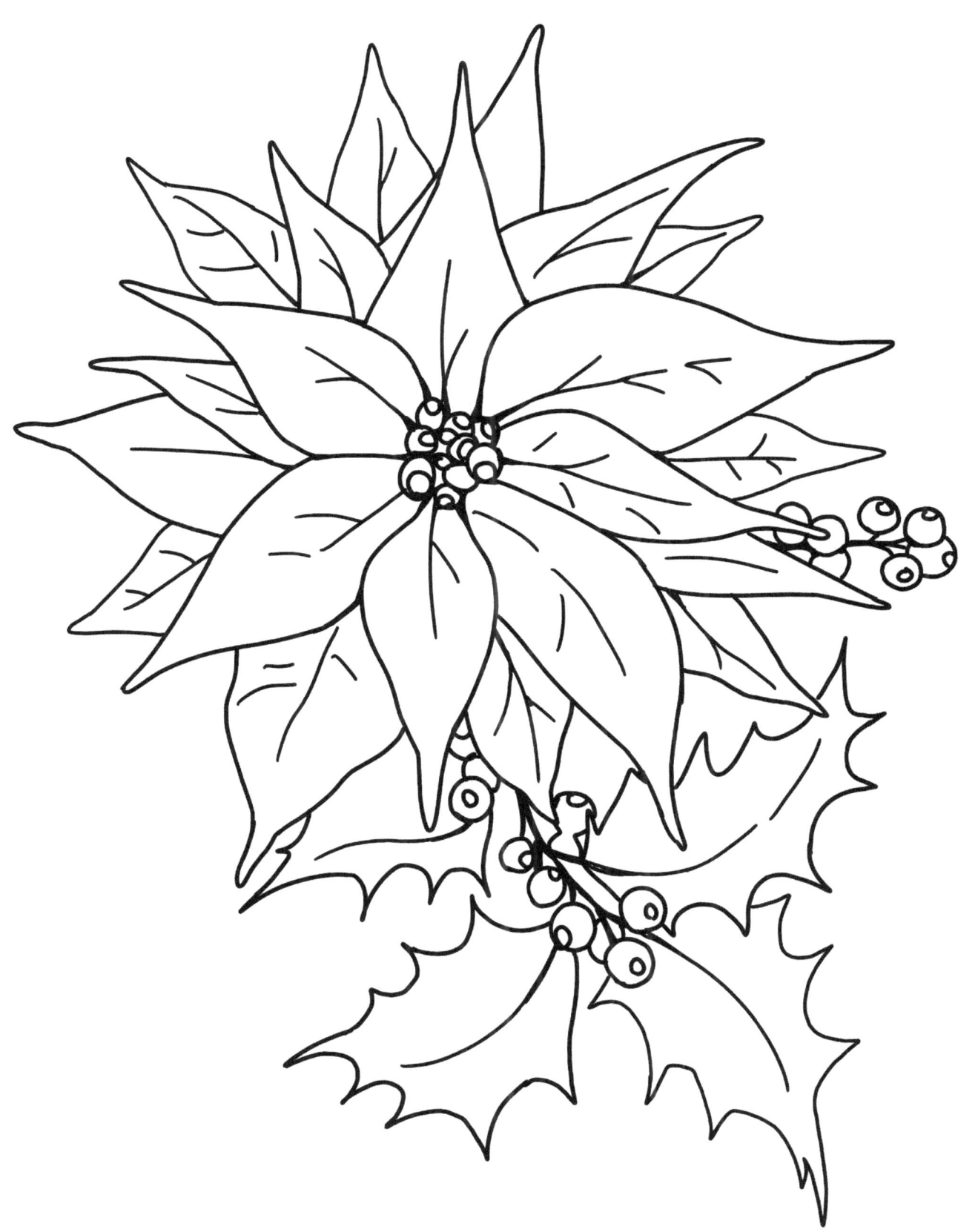

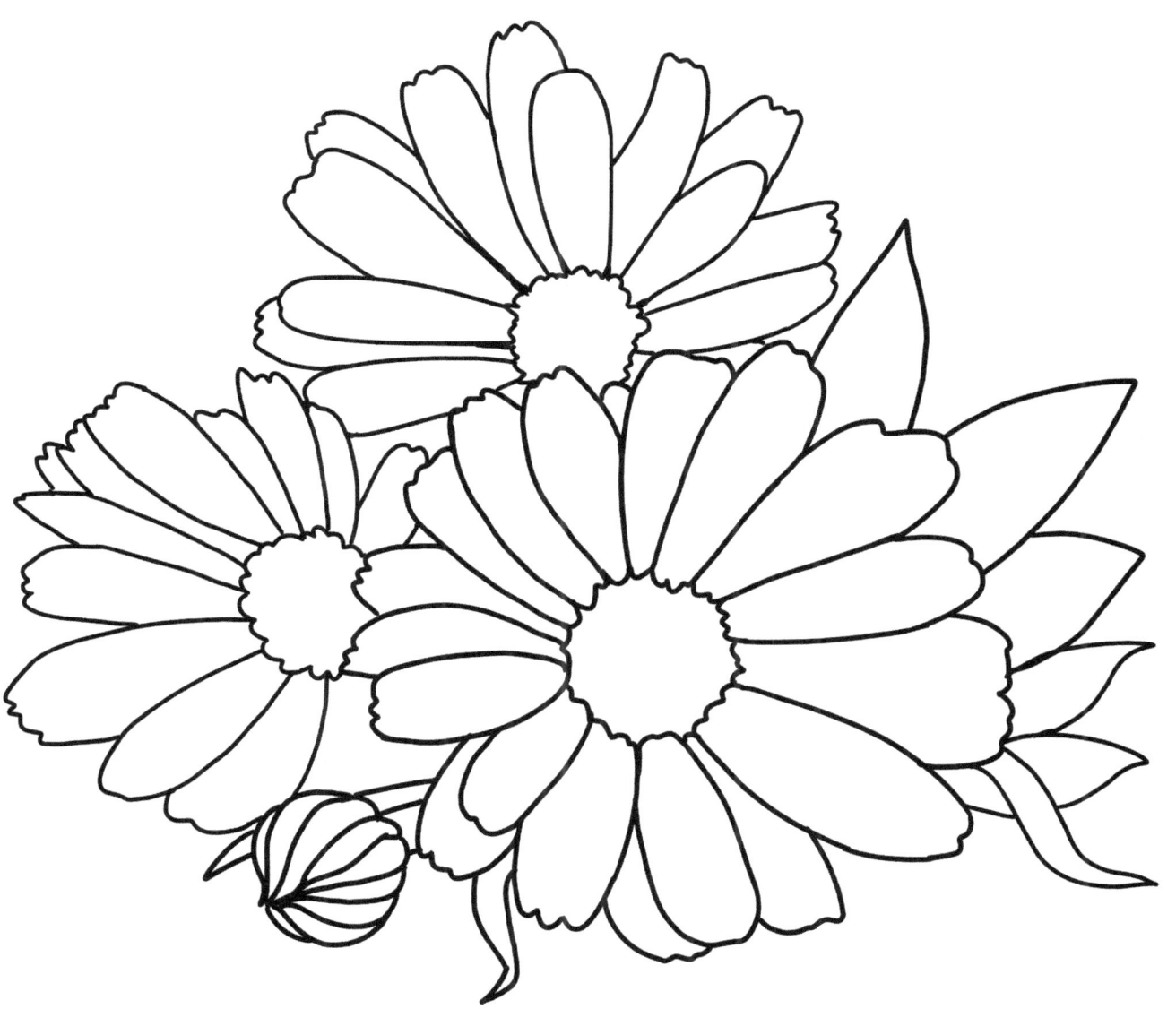

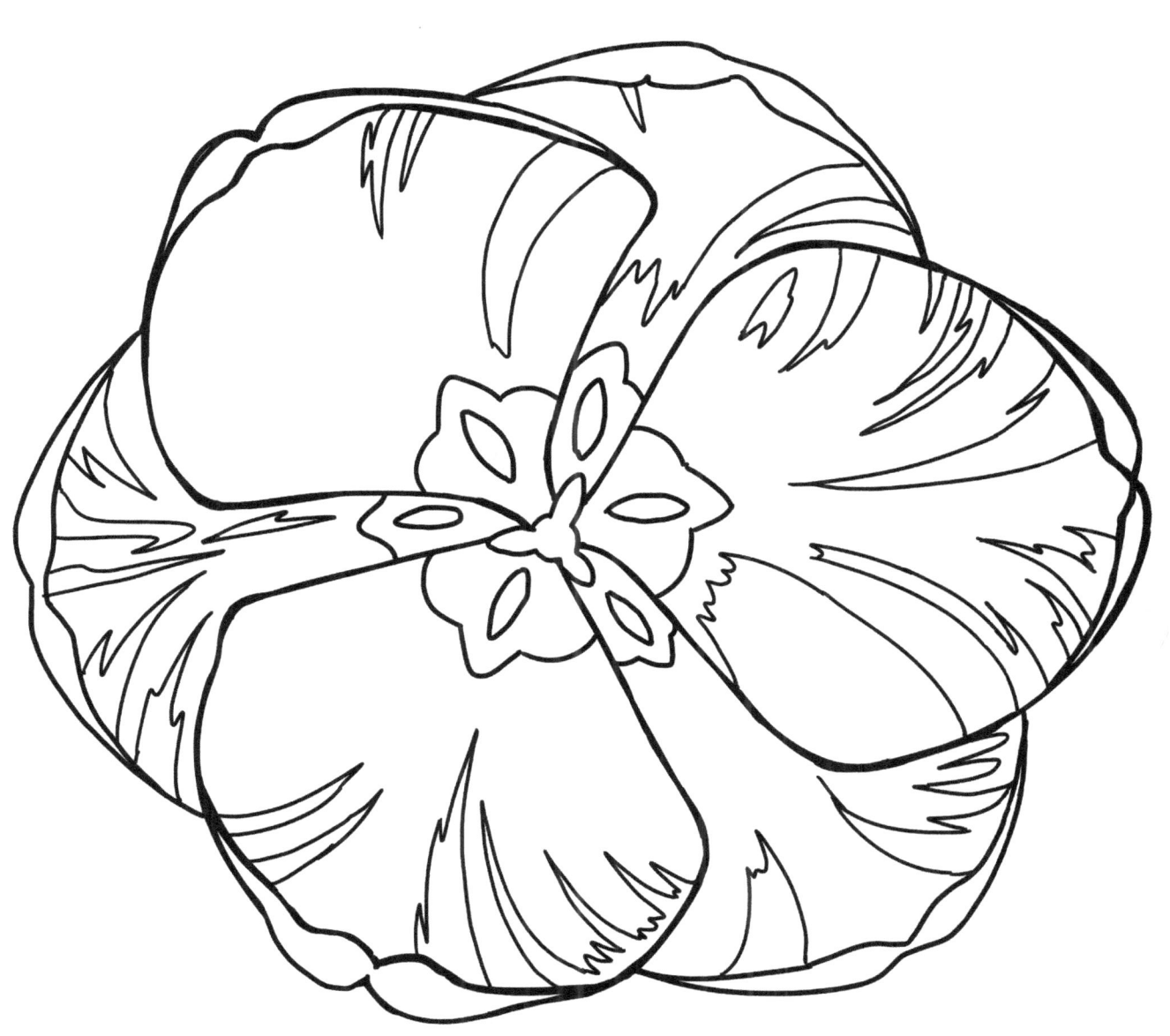

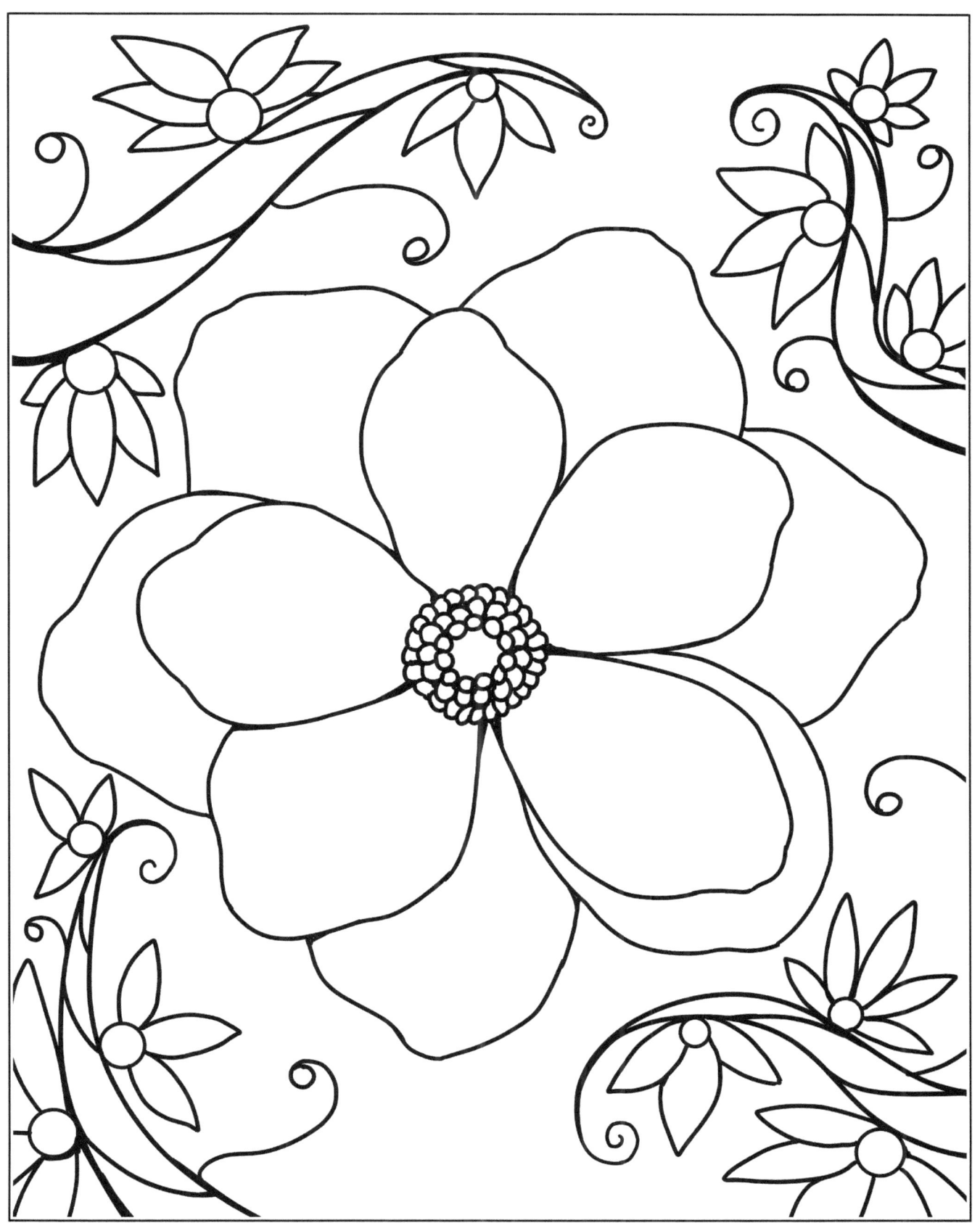

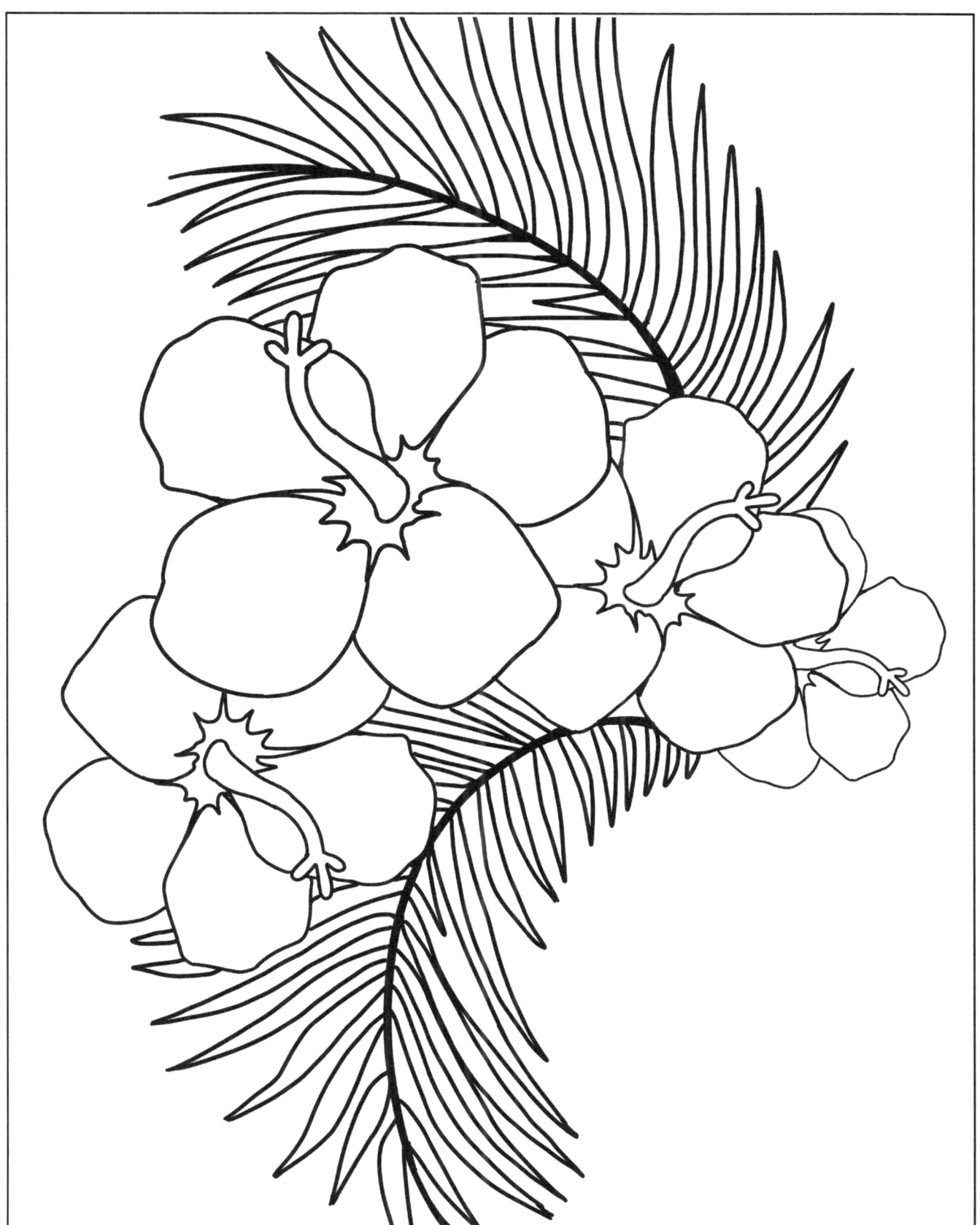

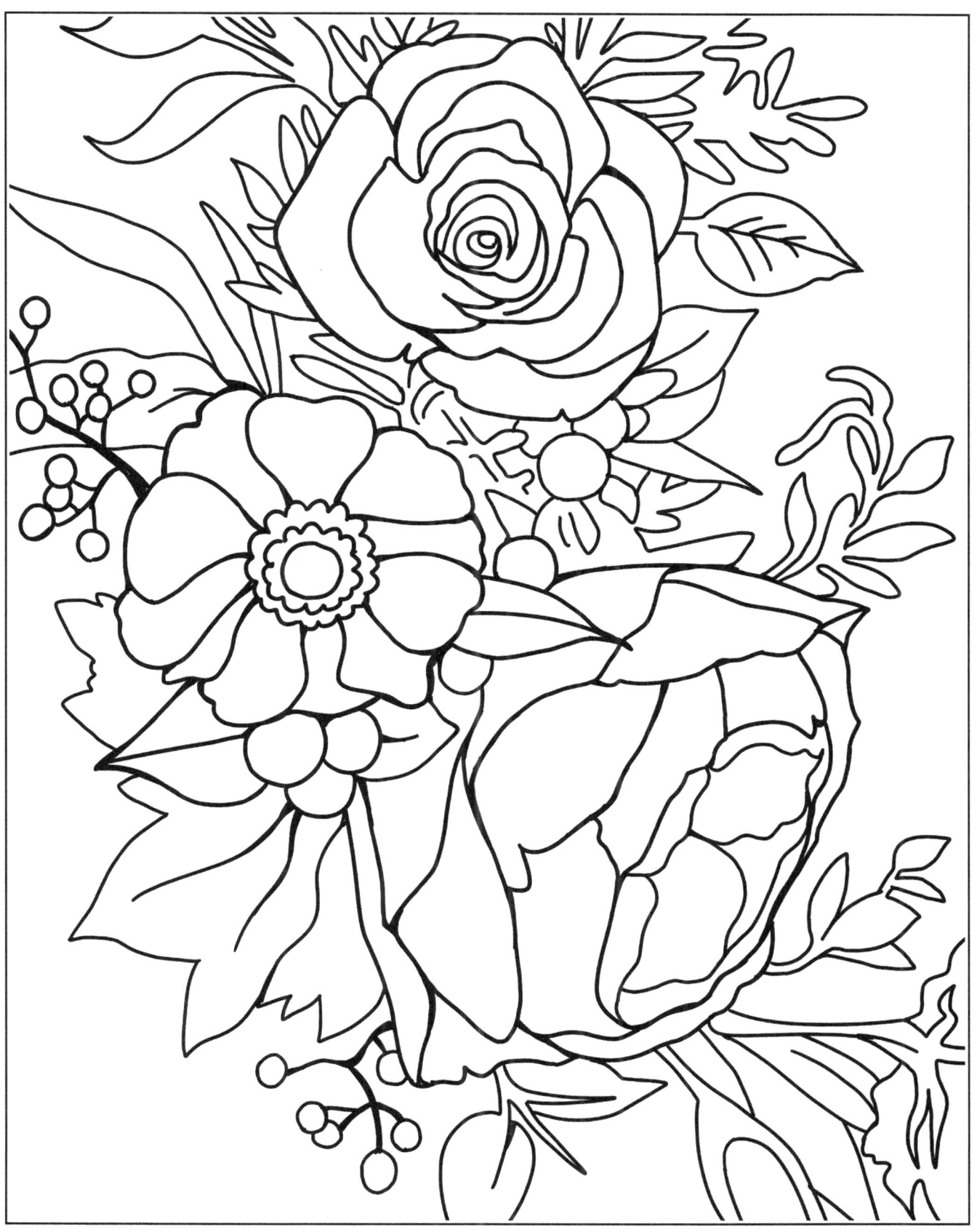

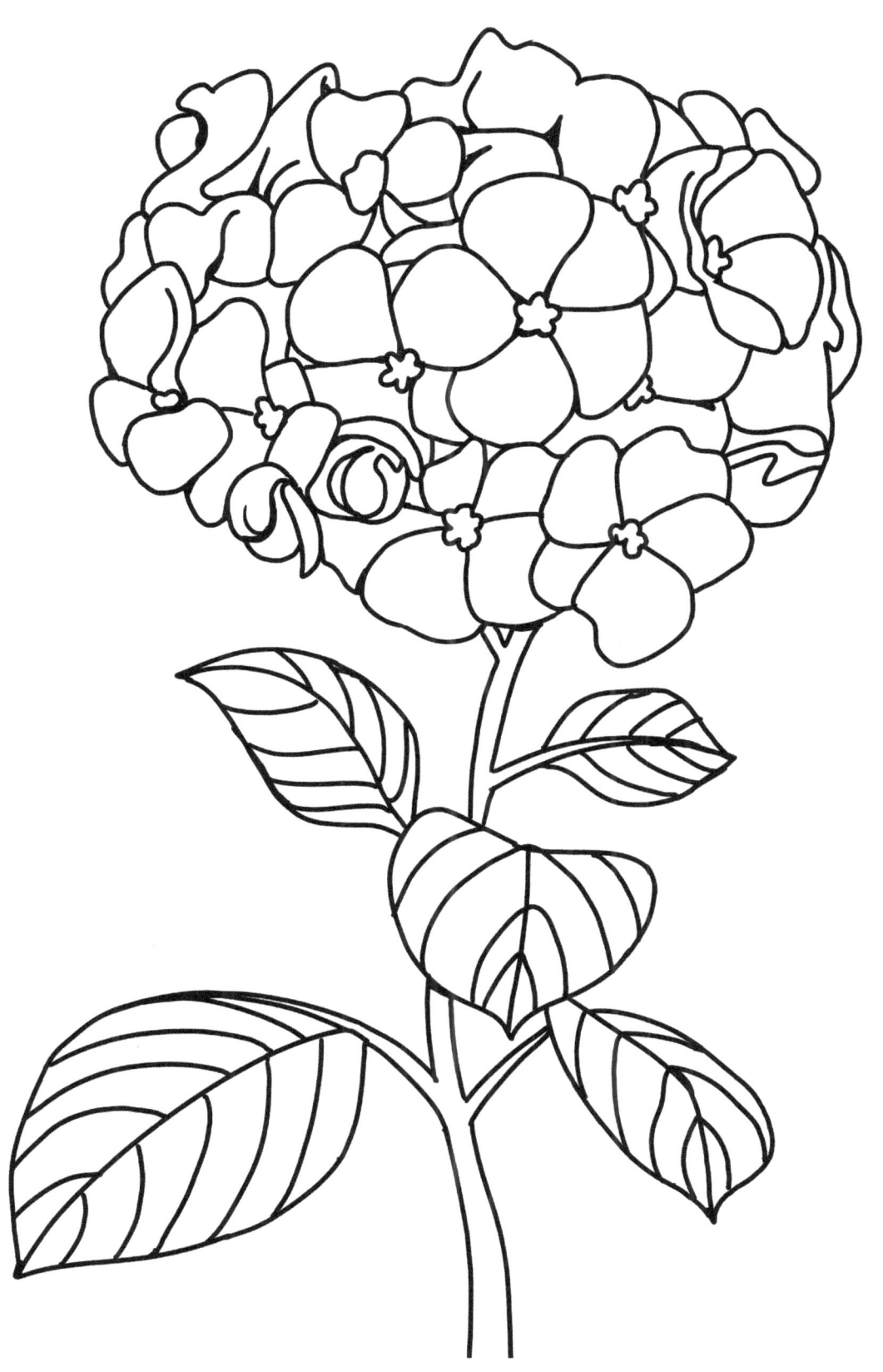

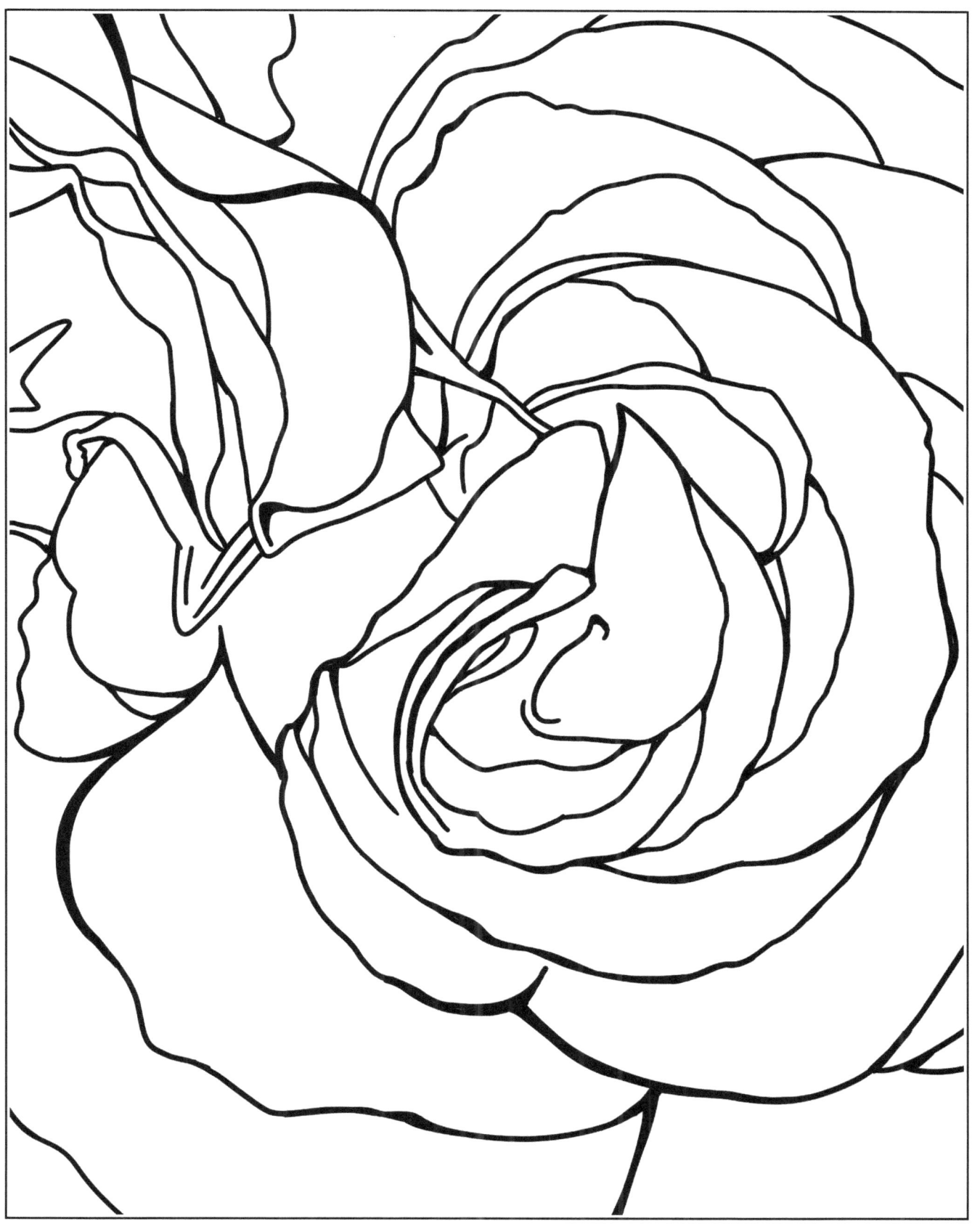

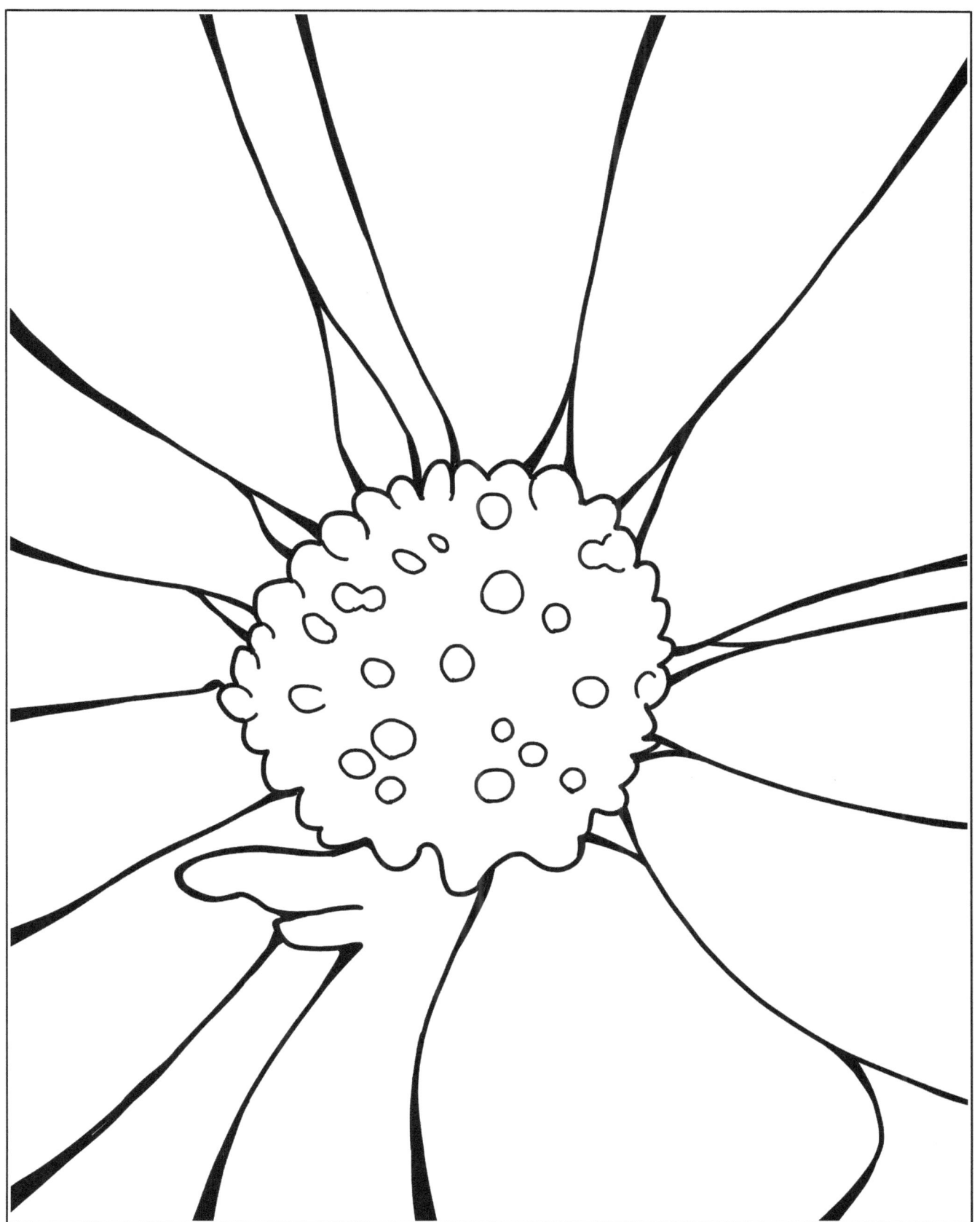

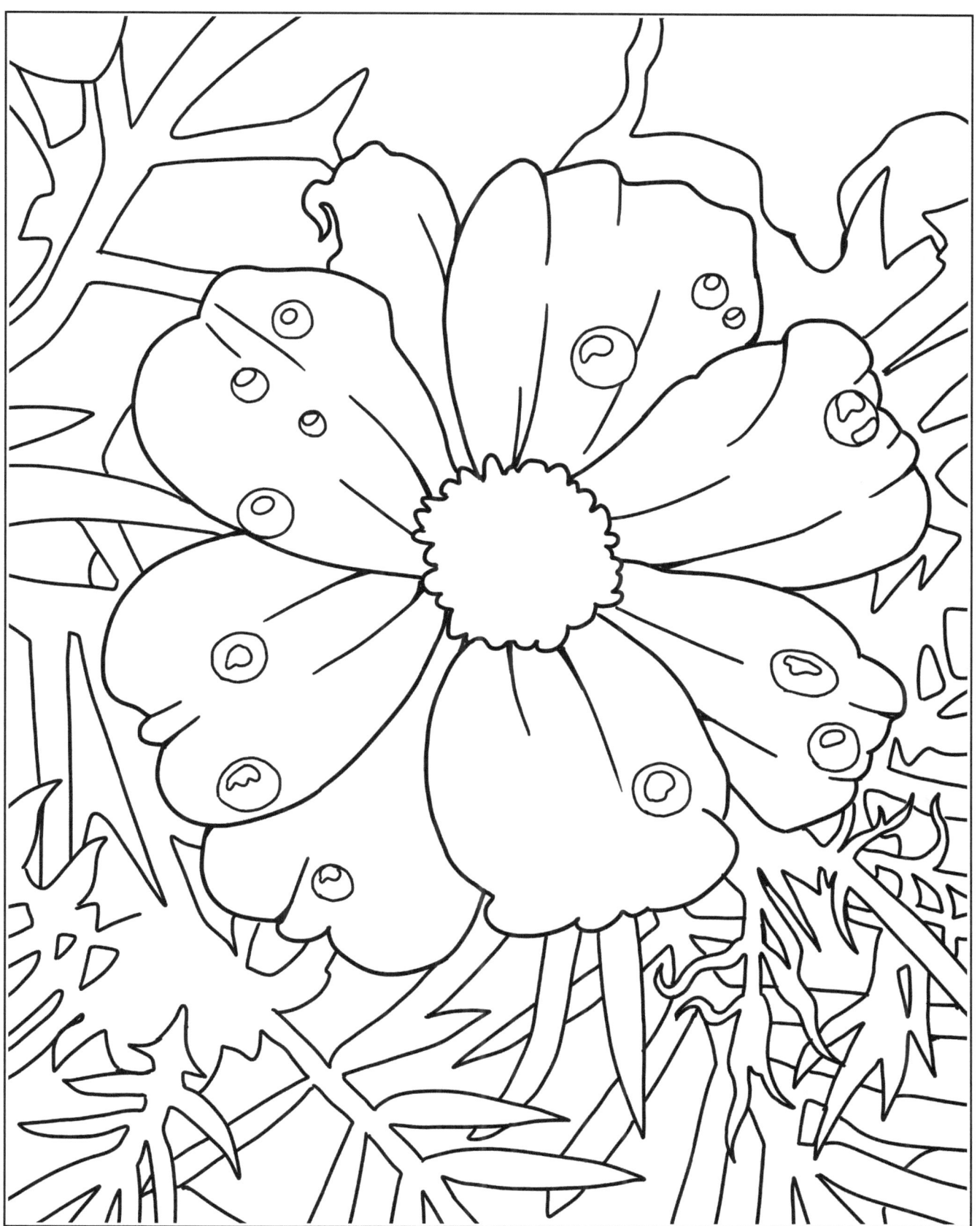

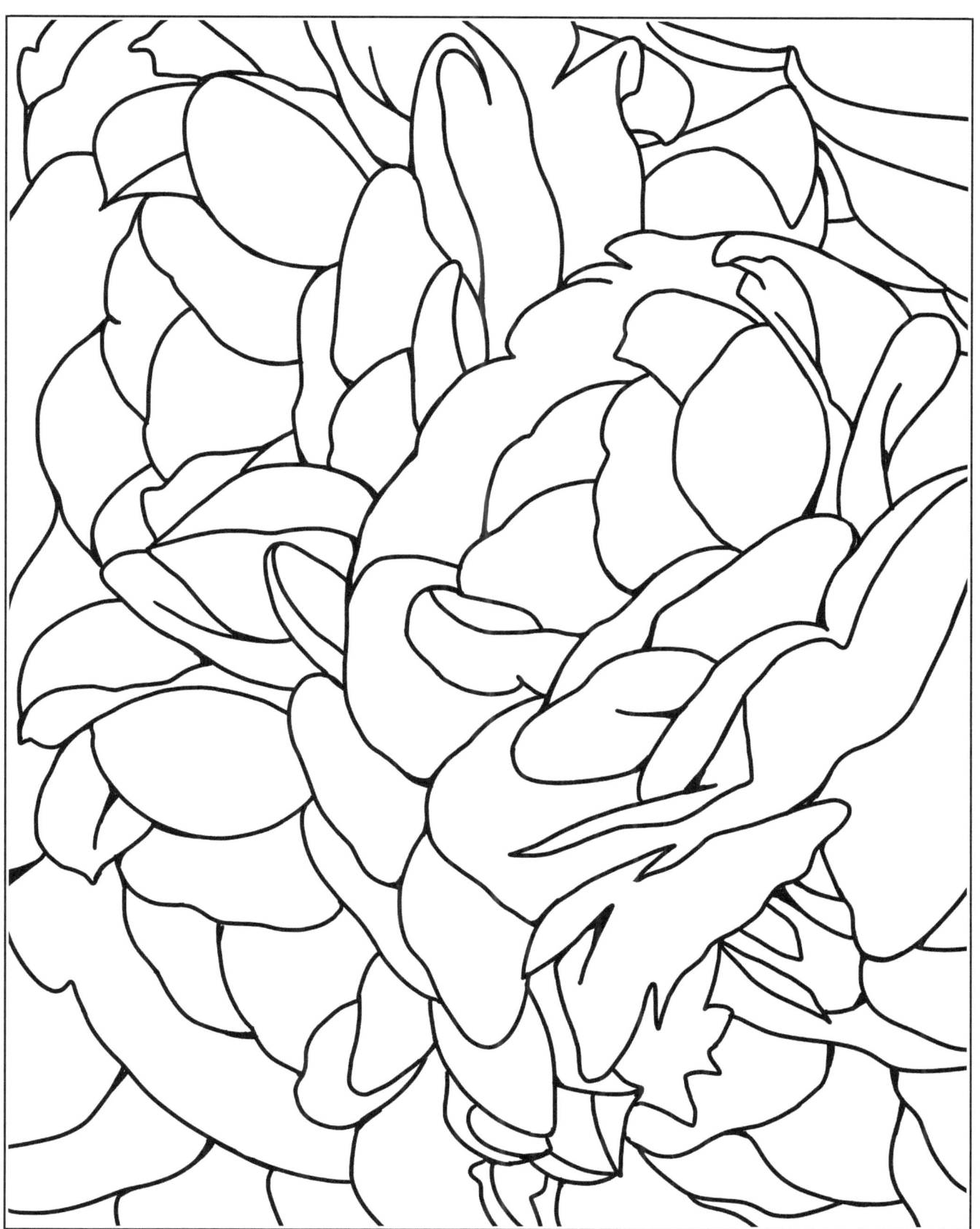

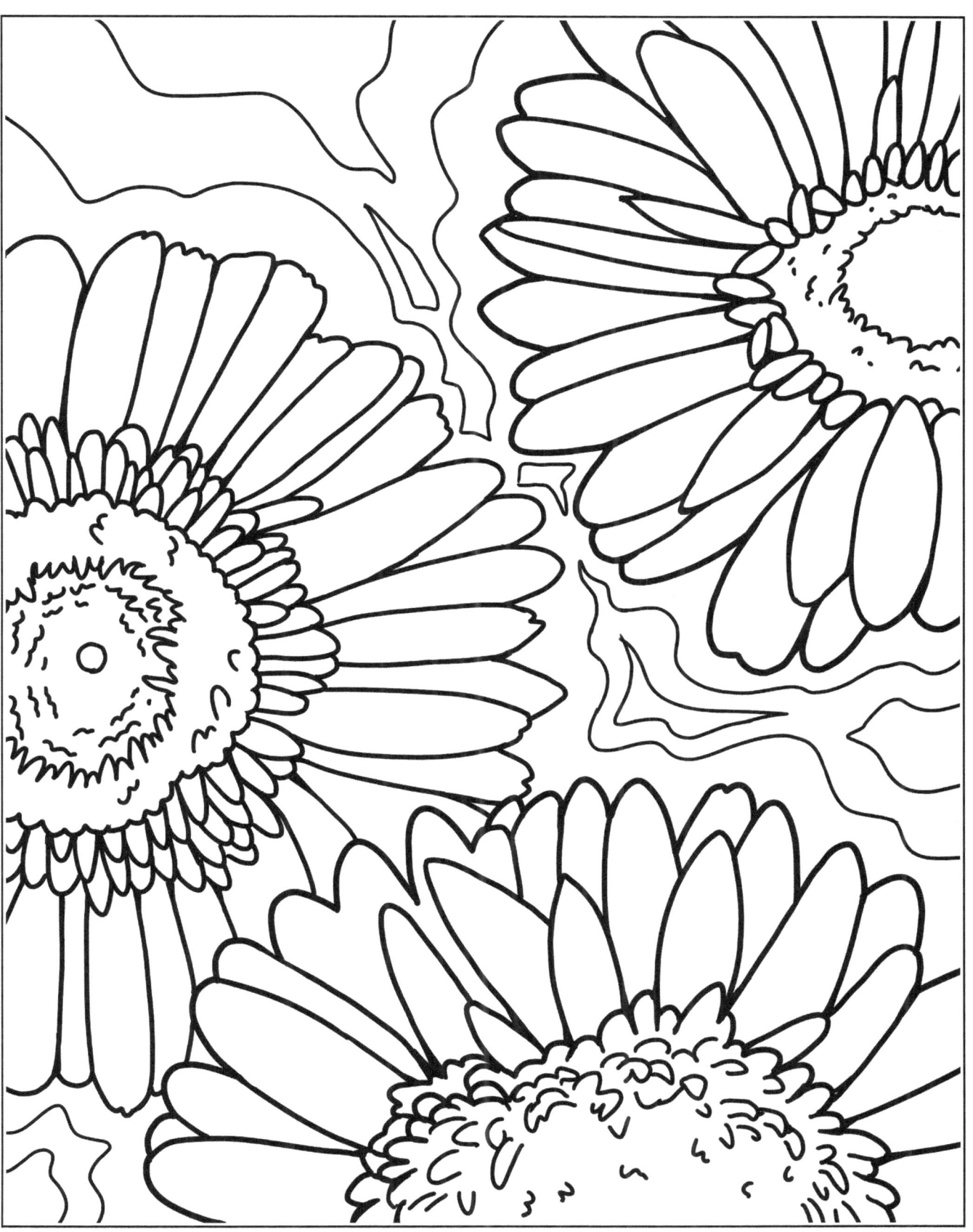

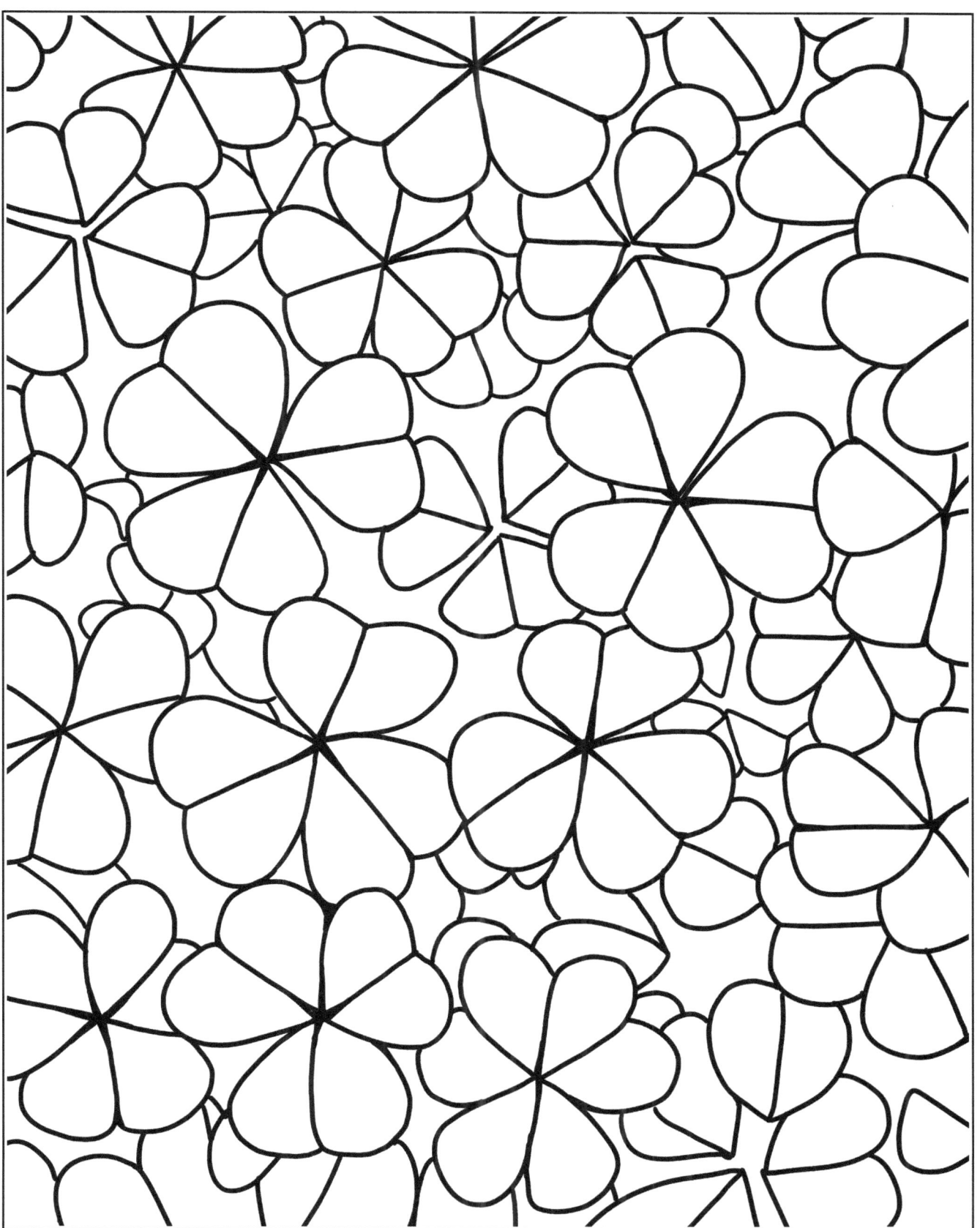

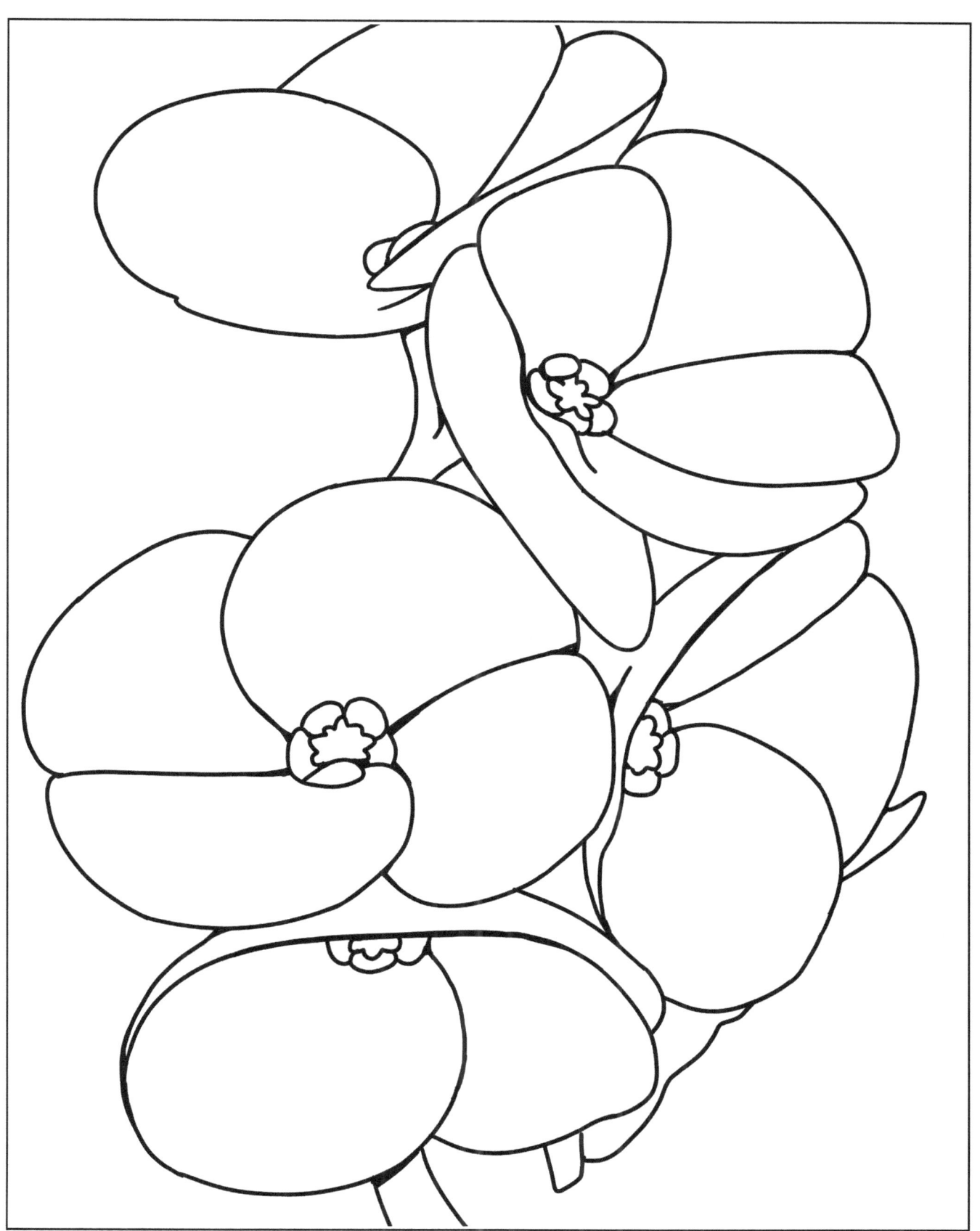

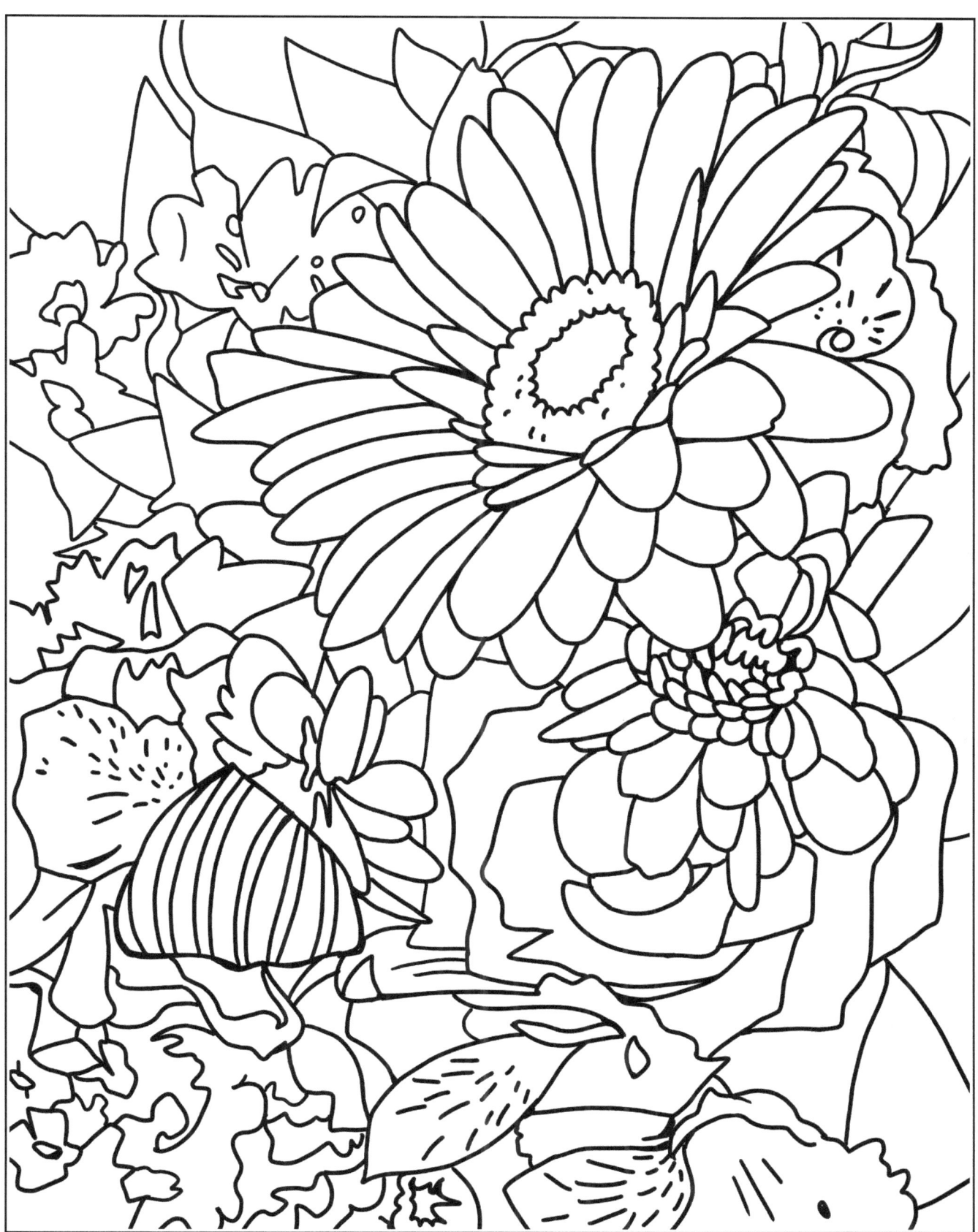

Micah Buzan is a self-taught animator and musician.

Go here for animation and music: **www.youtube.com/MicahBuzan**

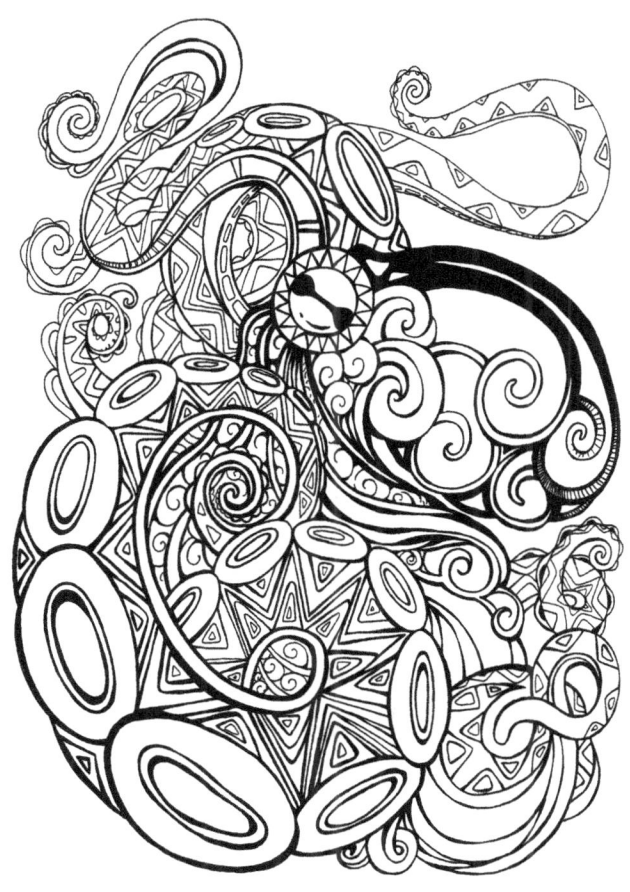

If you enjoyed the coloring book, consider leaving a review on amazon, as it helps!

Thank you so much for your support and have fun!

Order & Download more Coloring Books at:
https://www.micahbuzan.com/coloring-books/

Share your colored pages at:
https://www.facebook.com/groups/ColoringBooksByMicahBuzan/